Vietnam
Documented

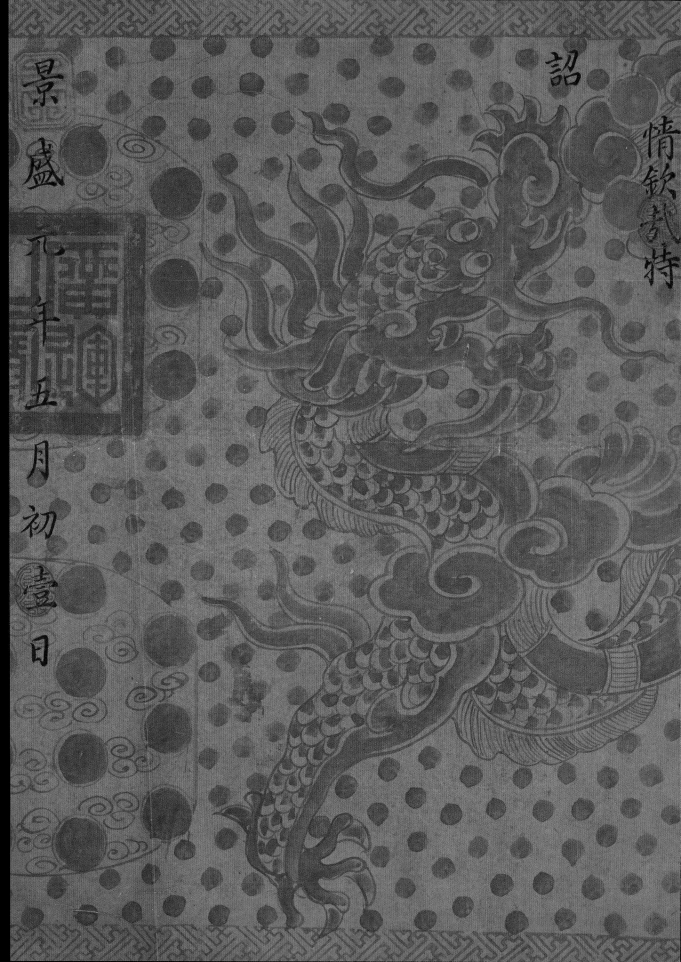

詔

情欽軼特

景盛

景盛元年五月初壹日

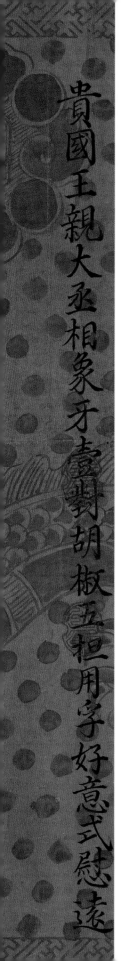
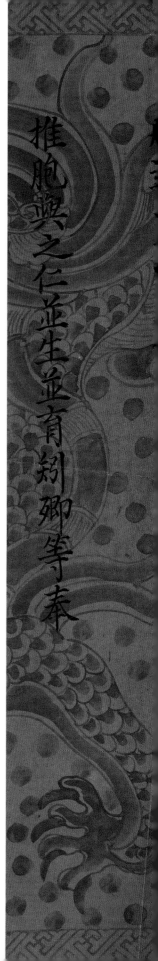

Vietnam Documented

The British Library's Vietnamese Collection

Sud Chonchirdsin

RIDGE BOOKS
SINGAPORE

BRITISH LIBRARY

Published under the Ridge Books imprint by:

NUS Press
National University of Singapore
AS3-01-02
3 Arts Link
Singapore 117569

Fax: (65) 6774-0652
E-mail: nusbooks@nus.edu.sg
Website: http://nuspress.nus.edu.sg

ISBN 978-981-325-188-5 (paper)

A catalogue record for this publication is available from the British Library, UK
and the National Library, Singapore

Designed by: Jonny Davidson
Printed by: Markono Print Media Pte Ltd

Contents

KIM ĐỒNG

Preface

When I was appointed curator for the Vietnamese collection at the British Library in May 2005, I had only a very sketchy idea of what this collection held. From the beginning, I realised that it was relatively small in comparison with many other collections in the Library, especially those in the South East Asian section from countries that were formerly parts of the British Empire. The Library does not hold a large number of heritage items, such as old manuscripts or printed books; however, once I started to explore, I was amazed to discover how rich and inspiring the material was.

The collection was formed during the early years of the Cold War, in the early 1950s, and then saw further development during another important juncture of history, the Vietnam War, in the 1960s. Thus the earlier acquisitions are rich in Vietnam War material. It is remarkable how much is revealed in the Hanoi regime's publications about specific aspects of Vietnamese society during this difficult and controversial period of its history, through both the text and the powerful images they contain.

Over the fifteen years of my curatorship I also discovered how incredibly fortunate and privileged I was to have been able to see, handle and make use of many of the valuable items in our collection. I can still recall how excited and nervous I was when I called up for inspection the precious and exquisitely illustrated manuscript of Kim Văn Kiều, created around the last decade of the nineteenth century. Since I was trained as a historian, specialising in Vietnamese history, I was touched when I first had the opportunity to handle and examine a late seventeenth-century scroll, possibly relating to Lord Trịnh Tac of the Trịnh family. You are never fully prepared for the excitement when you discover unexpected gems in your collection.

Over the six decades since its formation, the Vietnamese collection at the British Library has constantly expanded. It holds nine manuscripts, all fully digitised, over 11,000 books and about

220 titles of periodicals. During my time at the Library, I also witnessed positive changes in the quality of publications from Vietnam. Long gone is the poor quality, yellow paper from which many of our early printed monographs were produced. Most of the more recent books in our collection are printed on reasonably good-quality paper and often contain beautiful illustrations. This change reflects the major transformation in Vietnam from its bitter years of civil war into a more prosperous and stable society. All aspects of the contemporary country can be explored more fully through our comprehensive collection.

Inspired by the richness of the material, I started to contribute to the Library's popular Asian and African Studies blog. My posts have attracted an increasingly wide readership, and this has encouraged me to compile them as a book. I have chosen to arrange the articles by topic, rather than chronology, as it will make it easier for the reader to develop an overall understanding of the content of the collection. I hope that these posts will inspire readers who are interested in Vietnamese studies to explore the British Library collection in more depth. You never know when the impact of an advertisement or a cartoon drawing in an old and brittle Vietnamese newspaper of the 1960s may stimulate you into undertaking more serious research!

NOTE: All translations from Vietnamese are by the author unless otherwise stated. All images are from the British Library collection and the Library's shelfmarks for each item are given at the end of captions.

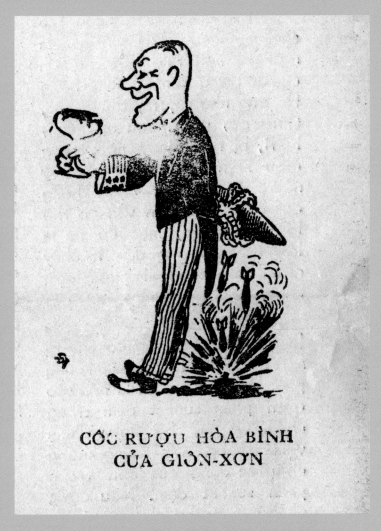

Vietnam War cartoon, poking fun at US President Lyndon B. Johnson ('Johnson's toast for peace'). *Khoa học thường thức*. SU220/13 (15 May 1965), p. 8.

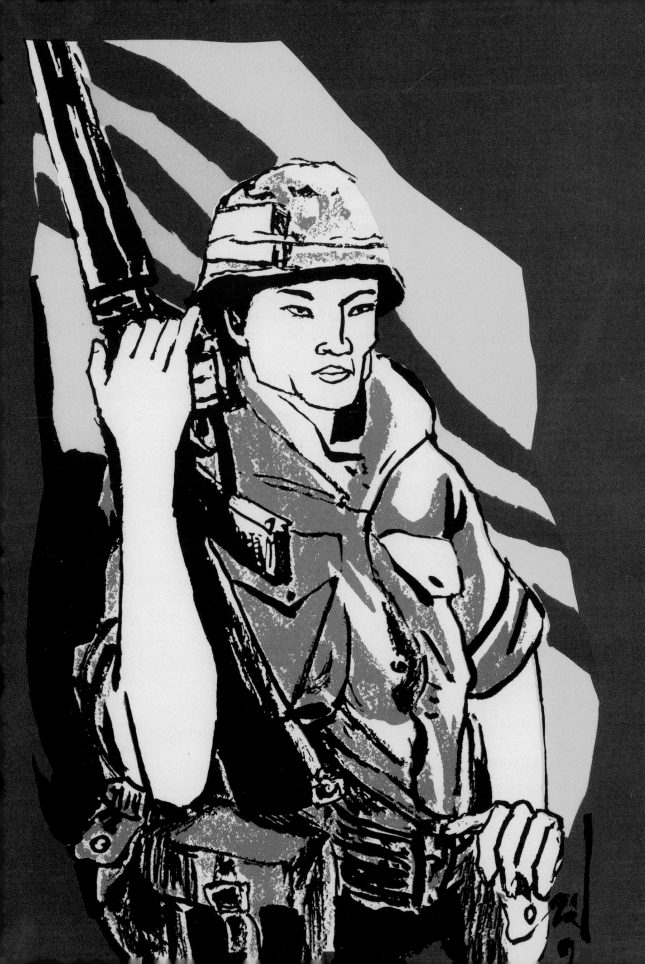

Introduction

One of the major challenges for a curator is to gain knowledge of the entire content of your collection and to make it to come to life for readers. As a curator for the Vietnamese collection, it took me at least two years at the beginning of my curatorship to get to grips with what the collection holds. It has been my task to introduce material ranging from a late seventeenth-century scroll to contemporary newspapers and modern prints to our readers.

Vietnam has a history dating back over a thousand years, and the British Library collection can only reflect a small part of that history. However, the material still represents the major incidents of Vietnamese society and history. Our collection includes a relatively small number of manuscripts which date back to Vietnam under the feudal rule of the seventeenth and eighteenth centuries and the following period, when Vietnam was ruled under the Tây Sơn brothers (r. 1778–1802). Three remarkable manuscripts from this period – the Trịnh Lord's letter to the English East India Company and two royal edicts of Emperor Cảnh Thịnh (r. 1792–1802) to Lord McCartney – record the arrival of the West during the expansion of mercantilism to this part of South East Asia and also how local rulers handled and exploited foreign visitors.

After over two centuries of political division of the kingdom from the sixteenth to eighteenth centuries, in 1802, Vietnam was eventually unified under the Nguyễn dynasty (1802–1945). The new rulers kept the tradition of seeking political acceptance and legitimacy from its more powerful neighbour – namely China, at this time under the Qing dynasty (1644–1911) – through the tribute system. An exquisitely illustrated manuscript in our collection, *Bắc Sứ Thủy Lục Địa Đô* or, in Chinese, *Beishi shuilu ditu* ('The northwards embassy by land and water from Hanoi to Beijing'), is a travel diary of the Vietnamese diplomatic mission to Beijing in 1880, which represents this tradition (see page 41). The written descriptions and beautiful illustrations record in fascinating detail

Vietnamese letter, probably from Trịnh Tac (r. 1657–82) of Tonkin (North Vietnam) to the East India Company, *c.* 1673. Sloane MS 3460.

the landscapes, temples and other features of interest which they came across during their journey.

Some aspects of the Nguyễn dynasty's adoption and adaptation of Chinese court traditions and cultures can also be studied in our collection. *Tuồng*, or classical theatre, is thought to have developed in the Vietnamese court of the Trần dynasty in the thirteenth century, and had some similarities to Chinese opera. The first four reigns of the Nguyễn dynasty saw a revival of this court performance. *Tống Từ Minh Truyện*, a copy of which is in our collection, is a ten-volume set of about fifty Tuồng plays written during the reign of Emperor Tự Đức (r. 1847–83), which illustrate well the peak of this art form.

It would be ignorant to talk about art and literature of the Nguyễn dynasty without mentioning one of the greatest pieces of Vietnamese literature: *Truyện Kiều*, or *Kim Văn Kiều*. Composed by Nguyễn Du in the early part of the nineteenth century, *Truyện Kiều* has become the paragon of Vietnamese literature. Our unique manuscript of this epic poem was created in around 1894 and has the most exquisite illustrations, which depict different scenes from the moving story (see pages 54–57). Apart from art and literature, our manuscript collection also reflects regional beliefs and customs, many of which were still strongly followed in the twentieth century under French rule. For example, three imperial edicts of Emperor

Khải Định (r. 1916–25) record the practice of deification of local spirits, a tradition which still survives in modern-day Vietnam.

Even though we do not hold official French colonial material, other types of source material created during French rule can be found by those interested in studying Vietnamese society during this period. For example, the complete three-volume set of *Introduction générale a l'étude de la technique du peuple annamite* by Henri Oger (Paris: Geuthner Librarie-Éditeur, 1909–11) is a rich source recording life of the Vietnamese and social history in the North at the end of the nineteenth and the beginning of the twentieth centuries.

Source material in our Vietnamese collection from the beginning of the twentieth century to the pre-Cold War period is limited. Most of the material relating to this period in our collection comprises Bibles translated into *quốc ngữ*, the Vietnamese national writing system, and printed mainly from the French mission in Hong Kong. *Quốc ngữ*, or Vietnamese written in Latin script, was invented for religious purposes in the mid-seventeenth century by Alexandre de Rhodes, a Jesuit priest from Avignon who worked in Vietnam from 1620. It was officially introduced as a writing system in Vietnam in the second half of the nineteenth century under French colonial rule and has subsequently become the national writing system. For those interested in the development of the writing system, we hold a copy of the *Dictionarium Annamiticum Lusitanum et Latinum*, a trilingual Vietnamese–Portuguese–Latin dictionary compiled by Alexandre de Rhodes and published in Rome in 1651.

When the Cold War spread to South East Asia in the 1950s and Vietnam became a war-torn battlefield of the 1960s, there was an urge in the West to learn more about this region. The British Library started to build up its Vietnamese collection during this period and it is therefore not surprising to find that the bulk of our early collection is related to the Vietnam War period. We acquired official publications from both the northern and the southern regimes in the 1960s and 1970s, but materials from the North outnumber those from the South. Among these publications, the most interesting ones are arguably local or provincial newspapers from North Vietnam between 1964 and 1965. None of these is complete and all of them

Publications from
North Vietnam:
Văn nghệ, Hanoi, no. 6, 1961. 16684.a.1.
Văn nghệ quân đội, Hanoi, December 1962. 16684.a.3

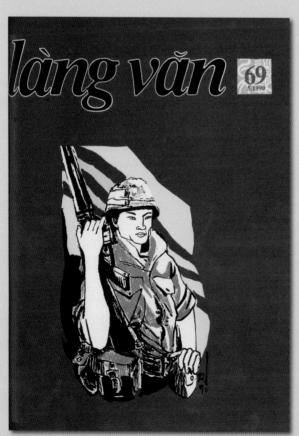

Làng Văn, Toronto, no. 69,
May 1990, front cover.
16641.e.13.

were published by the Vietnamese Workers' Party (*Đảng Lao Động Việt Nam* – the official name of the Vietnamese Communist Party until December 1976) at provincial level. These local newspapers were used to spread anti-American and anti-South Vietnam regime propaganda. They also shared the task of propagating communist ideas to the Vietnamese at local level. Perusing them gives readers a wider picture of rural North Vietnam in the 1960s.

Whilst the communist regime in the North used the press for propaganda purposes down to the local level, the southern regime did not exercise its propaganda machine as vigorously. Anticommunist newspapers published in South Vietnam were mainly based in Saigon and the British Library holds a small number of these newspapers.

The end of the Vietnam War and the reunification of the country under the Hanoi regime in 1975 ignited a new wave of emigration as more Vietnamese decided to leave their motherland, become refugees and eventually settle in new countries. It was during this period that the overseas Vietnamese started to write about their plight as refugees and their new life in foreign countries. The British Library holds a number of post-Vietnam War publications by overseas Vietnamese, mainly in North America, Europe and Australia. These publications give a good insight into their nostalgia for their homeland and Vietnamese culture and their strong antagonism towards the communist regime in Hanoi.

Modern Vietnam can trace its roots back to the late 1980s when the Vietnamese Communist Party adopted a new policy of *Đổi Mới* or economic reform, along the line of reforms in the communist bloc led by the former Soviet Union and China. Our collection holds publications that reflect the major transformation of Vietnamese society at this time. The Library's collection of modern printed books from Vietnam is probably the largest in the United Kingdom. An understanding of the breadth of the collection will enable readers to undertake serious studies in relation to Vietnam, and will also give valuable insights into the development of Vietnamese political history and culture for the more general reader.

The formation of the Vietnamese collection

In the digital era, accessing information of any kind from a library takes just one click on your keyboard, and it is easy to forget how difficult this activity could be in the past. Half a century ago, this luxury was unimaginable, thanks not only to the state of technology at that time but also to the scarcity of source materials. The problem became even more acute when you were dealing with materials from a country that endured more than a decade of war such as Vietnam in the 1960s. The British Library went to great lengths during the 1960s in order to acquire publications from this war-torn and politically divided country.

The drive to acquire materials from Vietnam was mainly due to G. H. Spinney, who from 1948 was Keeper of the State Paper Room (which subsequently became the Department of Official Publications in the British Library). During the early 1960s Spinney campaigned vigorously to increase the collection of official publications in the State Paper Room, largely by utilising the mechanism of international exchange.

The Vietnamese collection was originally held in the British Museum's Department of Oriental Printed Books and Manuscripts. Unlike the large numbers of publications in Burmese and Malay from former British colonies in South East Asia, up to the 1950s the Vietnamese collection was very small. The Cold War and scarcity of information from remote communist-bloc countries compounded the difficulties in acquiring materials in both vernacular languages and English, and on 13 December 1960, H. A. Arnold from the State Paper Room wrote to Kubon & Sagner, a book supplier in Munich, to see whether it would be able to supply materials from Mongolia, the USSR, North Korea and North Vietnam for the Library.

For sourcing materials from North Vietnam, the British Museum enlisted the help of Hanoi's main ally, China, to find ways to contact

relevant institutions. The National Library of China in Beijing eventually provided Spinney with contact details for North Vietnam and in May 1959, he wrote a long letter to the Director of the National Library in Hanoi to ascertain whether the latter would be interested in establishing book exchanges with the British Library. Parts of Spinney's letter are worth quoting here:

> During a general review of our accessions from Asiatic countries, we were disturbed to find that we have so far received no official publications from the Government of the Democratic Republic of Vietnam ... and we need therefore urgently to acquire documentation from official sources in the Democratic Republic of Vietnam to provide a basis for research ... You will readily appreciate that in acquiring such documentary material we have to think in terms of the requirements of posterity as well as of current research.
>
> (G. H. Spinney to the Director of the National Central Library, Hanoi, 4 May 1959)

There is little evidence that Spinney's request was well received by Hanoi, and further approaches were made in subsequent years, as shown by copies of letters held in the Library's archives from H. A. Arnold to the Cultural Attaché of the Embassy of the Democratic Republic of Vietnam in Moscow (dated 2 August 1961, 27 August 1962 and 15 July 1963).

Despite these setbacks the Library persevered in its attempts to build up the national collection in Vietnamese. In the 1960s, this task was split between two departments: the State Paper Room was in charge of acquiring official publications from Hanoi, while the Department of Oriental Printed Books and Manuscripts collected printed books on social sciences and humanities. They used book dealers in (West) Germany and Hong Kong, and occasionally bought directly from Xunhasaba, the North Vietnam state-owned book dealer. Requests were sometimes rejected by Hanoi, especially for official publications, with the reason being given that 'the item is not for export', a message that indicates the level of secrecy and control of information in this country. However, sporadic donations of materials were received from North Vietnam's diplomatic mission in New Delhi.

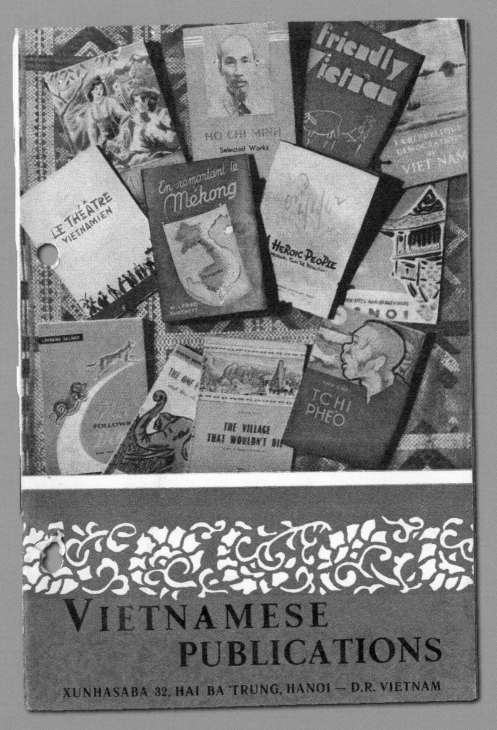

1962 catalogue from Xunhasaba, the state-owned book supplier in North Vietnam, received via Kubon & Sagner, a supplier in Germany. Y.P.2019.a.7445.

Towards the end of 1961, the Committee for Cultural Relations with Foreign Countries in Hanoi started to send some publications to the British Museum. Subsequently, the task was transferred to the National Library of Vietnam and the Library of Social Sciences in Hanoi, and this arrangement continues to the present day with the British Library. In January 1968, the newly established Central Library for Science and Technology in Hanoi offered a publications exchange programme with the Library but the actual dispatches only started in 1971.

Deliveries of books during the war years were never easy, and sometimes dispatches from London to Hanoi or vice versa did not arrive at their destination. Correspondence between Nguyễn Minh Tăn, the Vice Director of the Central Library of Science and Technology in Hanoi, and H. A. Arnold, the Keeper of the State Paper Room, illustrates vividly the problems experienced by the libraries in London and Hanoi. On 10 March 1973 Nguyễn Minh Tăn wrote to Arnold:

> We are happy to advise you that despite the savage bombing of Hanoi by the US, our Library as well as the Library for Social Science and the National Library are very safe. We were evacuated for some time but we are now back in Hanoi, and working normally ... We are currently experiencing some difficulties and cannot acquire some of your requested periodicals.

Arnold replied on 24 May 1973:

> It was good to hear from your Library again – Mr Tran Mai's last letter to me was dated October 10th, 1971 – and I was very pleased to learn that not only was your own Library safe from the bombing, but also the Library for Social Science and the Bibliothèque Nationale as well ... I can well appreciate that you are having many difficulties at the present time and that you are not in a position to send me some of the journals I have requested in the past. I am sure, however, that as conditions improve, you will send me whatever you can find.

The 'savage bombing' referred to was Operation Linebacker or the Christmas Bombing (18–29 December 1972) in which the US launched serious bombings over Hanoi to force the latter to negotiate a peace deal; eventually the Paris Agreement was signed on 27 January 1973.

Despite all the difficulties during the Vietnam War, material from North Vietnam continued to arrive in London through various channels. When the British Library was formed from the Library of the British Museum in 1973, the Vietnamese collection in the renamed Department of Oriental Manuscripts and Printed Books consisted of three manuscripts and about 800 printed books and some periodicals.

No formal contracts for book exchanges with any institutions in North Vietnam have been found in our archives but we can deduce from correspondence that the Library had exchange programmes with at least three libraries in Hanoi in order to acquire official Vietnamese publications on the economy, science and social sciences. It is interesting to note that the amount of printed material, both official publications and monographs, which the British Library received from North Vietnam underwent a noticeable increase from 1973. This might be related to the signing of the Paris Agreement in January 1973, which eased tensions and hence allowed almost normal daily activities to resume. At the same time, the British Library continued to acquire printed books from Vietnam on humanities, art and culture via book dealers in Germany and Hong Kong.

Unlike the situation with North Vietnam, throughout the war years the British government maintained a diplomatic relationship with the South Vietnamese regime in Saigon, and there was a Republic of Vietnam embassy located in London. The earliest evidence of an attempt by the then British Museum Library to establish book exchanges with South Vietnam is found in a letter from G. H. Spinney (Keeper of the State Paper Room, see page 17) to the Vietnamese embassy in London, dated 7 May 1959. In it, he mentions his lack of success in contacting the State Library of Vietnam in December 1958 regarding establishing a book exchange

Postcard to the Library of the British
Museum from the Committee for
Cultural Relations with Foreign
Countries, Hanoi, October 1968.

NUÔI TRÂU BÉO
Ảnh : Đào thiện V...
INFORMATION DEPARTMENT
COMMITTEE FOR CULTURAL RELATIONS
HANOI

Hanoi, October 1968

Dear friend,
We are happy to acknowledge receipt
of your reply to question on our
publications. We sincerely express
our thanks for your appreciated opi-
nions. We wish to receive more cons-
tructives critics.
Hoping closer relations.

 For the Information Department

Mrs. THU CÚC

NHÀ XUẤT BẢN MỸ THUẬT VÀ ÂM NHẠC HÀ-NỘI — NHÀ MÁY IN TIẾN BỘ

programme, and also reiterates the necessity of collecting material from South Vietnam.

Through the London embassy of the Republic of Vietnam and the Ministry of Foreign Affairs in Saigon, an agreement in principle was reached on 12 January 1960. Despite the absence of a formal exchange contract, from 1959 onwards the British Museum Library started to exchange both official publications and books with various South Vietnamese government ministries and departments. Negotiations between the two parties regarding the details of exchanges went on for some years, dealing with details such as whether or not the supply of back numbers of periodicals of any date could be arranged and included.

Finally, on 30 November 1962, the UK government and the government of the Republic of Vietnam agreed upon an Exchange of Notes concerning the exchange of official publications between the two governments. This agreement formed the basis for material collected from South Vietnam during the war years. The Directorate of National Archives and Libraries in Saigon was entrusted with the task of sending official publications from the Republic of Vietnam to the British Library.

The correspondence between the British Library and the Vietnamese embassy in London demonstrates that there was a regular exchange between the two institutions, and Saigon occasionally also sent a few monographs to the Library. However, it is quite surprising that the number of official serials and monographs from Saigon in our collection during the war period is much smaller than that received from Hanoi, considering that the UK only had diplomatic relations with the Saigon regime, and that the Republic of Vietnam was a 'free country'. The answer to this puzzle probably lies in the historian Nguyễn Thế Anh's observation that in the socialist North, where culture and literature were placed under the direction of the state, publications were often issued in large editions and played an important role in society. On the other hand, in the South, where free enterprise reigned, publishing benefited from the latest technical innovations but was often disorderly, with a proliferation of limited and poorly distributed editions.

PHẠM - VĂN - SƠN

VIỆT·SỬ
TOÀN THƯ

(Từ Thượng-Cổ đến Hiện-Đại)

TỦ SÁCH SỬ HỌC

Publication from Saigon, 1960. 16622.a.12.

It should also be noted that all printed material for export in the North came under the state-run enterprise, Xunhasaba. Even though the export of printed material was subject to strict rules and controls, the state distributor worked more efficiently than the private suppliers in the South during the war years. As a result, the British Library sometimes received duplicates from the North which were then donated to the embassy of Vietnam in London for their own use, illustrating how rare such material was, and how the gathering of such essential information was valued by these two war-torn states during the Vietnam War.

All these attempts by those who were involved in acquiring material from both sides of Vietnam have paid off. Today, the Vietnamese collection in the British Library is probably the largest in the UK. We continue to add to the collection of modern printed books, and to date we have about 11,000 items in the collection, covering important fields in the social sciences and humanities such as linguistics, law, literature, history and anthropology.

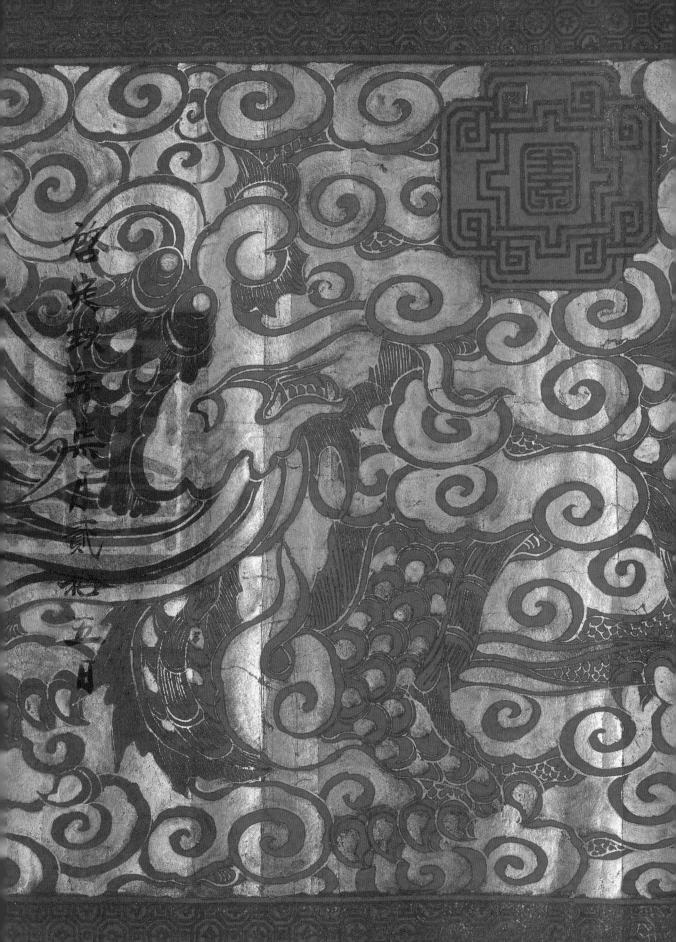

Vietnamese manuscripts

The number of manuscripts in the Vietnamese collection at the British Library is relatively small in comparison with other South East Asian manuscript collections. Nonetheless they give a good representation of the historical and traditional literary styles of Vietnam and the region, as far as writing methods and formats are concerned. Vietnamese manuscripts in our collection can be found in the form of both scrolls and bound books.

The historian Alexander Woodside has pointed out in his classic work *Vietnam and the Chinese Model* that the literary world of the Vietnamese, especially that of the court and scholars, was inspired by Chinese scholarship, and that therefore the traditional Vietnamese literary styles were heavily influenced by Chinese literary traditions. They shared some similar characteristics. First and foremost, Vietnamese literati learned and wrote in Chinese (*chữ Hán* in Vietnamese), even though the Vietnamese later invented their simplified script based on Chinese script (*chữ Nôm* in Vietnamese). Vietnamese manuscripts in our collection are all written in *chữ Hán* or a mixture of *chữ Hán* and *chữ Nôm*. The Vietnamese also wrote on scrolls as well as in bound books, in the same fashion as other East Asian literary cultures.

This section introduces some of the most outstanding Vietnamese manuscripts in the British Library collection and sets them in their historical and cultural backgrounds. All manuscripts discussed here have been fully digitised and readers can now view them in their complete form on the British Library website.

Scrolls (Sắc phong)

The six Vietnamese scrolls in our collections date from the late seventeenth century to the early part of the twentieth century. They are letters or royal edicts from the Vietnamese rulers of the period and were issued for various reasons, but they all bear the

same characteristics, which symbolise the political power of the issuer: the five-clawed dragon pattern on yellow paper, which was reserved solely for imperial use, and which was stamped with the issuer's seal.

A Trịnh Lord's letter to the English East India Company

During the Later Lê dynasty (1428–1788), Vietnam was effectively divided into two parts. For over two centuries – from the middle of the sixteenth to the middle of the eighteenth century – the Trịnh Lords ruled the northern part (referred to in Vietnamese history as *Đàng Ngoài*) and the Nguyễn Lords had power over the southern part (*Đàng Trong*) of Vietnam, while the Lê emperors had no real political power at all.

Letter from Trịnh Tac (r. 1657–82) of Tonkin to the
East India Company, *c*. 1673. Sloane MS 3460.

The oldest manuscript in the collection, from the founding collection of Sir Hans Sloane of 1753, was probably written by the Trịnh ruler of Tonkin (North Vietnam) in the late seventeenth century (Sloane MS 3460). It is a long scroll of yellow paper, beautifully illuminated in silver, written in the Vietnamese language in Hán-Nôm (adapted Chinese) characters, and bearing a large square red ink seal. Unfortunately, the first part of the scroll is missing, and some of the characters in the remaining part are illegible, and it is therefore impossible to establish the precise date of this manuscript.

Dr Li Tana of the Australian National University examined images of the manuscript in April 2018. She has transcribed and translated its contents, and is of the opinion that it was probably written under the command of Trịnh Tac (r. 1657–82) and was sent to the English East India Company (EIC) some time in 1673, following the arrival in Tonkin in 1672 of the first EIC ship. Foreign traders always sought assistance from local powers to facilitate

their commercial missions, and in return the local lords also tried to benefit from these foreign visitors, especially their technical knowhow on modern technology, as the content of the Trịnh lord's letter clearly demonstrates:

> [Overseas merchants visiting us] have been many but only Holland has come ... [three characters not legible]. It has acted in both friendship and righteousness. [They] sometimes offer pearls and beautiful presents and sometimes send craftsmen who are specialised in cannon casting. This kindness is above all rulers. Although your country has only just begun interactions with us, we treat all countries equally with compassion and good will. Recently your head trader brought one iron cannon and two bronze cannons. The bronze ones broke as soon as they were tested. [They] were definitely not of solid and excellent quality. [We therefore] have returned them to the ship captain but he has not yet taken them back. If you are arranging for ship[s] to come next year, [please] bring amber either in pieces or stringed together with real pearls for us. We will pay [you] accordingly right away. [This] will be of benefit to both sides. [Please] also send cannon casting craftsmen so that the craftsmen from Holland cannot monopolise this skill. This way our friendship will last forever. [We are sending] 560 catties of raw silk for the two iron cannons which we received last year. Please buy us 50 hoc (= 50 kg) big-sized amber, plus 5,000 pieces of stringed amber. Written in the mid-winter

(translated by Dr Li Tana, edited by Dr Geoffrey Wade).

By the early seventeenth century, commercial competition among European mercantile states had expanded to Asia, and South East Asia was also targeted for its rich resources. Vietnam was located in a commercially strategic maritime location and many European traders started to visit the kingdom to seek commercial opportunities. The EIC sent its first delegation from its Japanese base of Hirado (near Nagasaki) to Vietnam as early as 1613 amid vigorous competition with the Dutch East India Company (VOC) and other West European nations. Hirado had been an important

port of call for ships between Japan and the Asian mainland since the Nara period in the eighth century, and both the EIC and the VOC had their 'factories' (trading posts) there.

In 1672, the EIC sought to establish a factory in Tonkin, as a liaison base for the export and import of British traders' goods to China, Japan and maritime South East Asia. On 25 June 1672, the EIC ship *Zant* was sent from Bantam in Java to Tonkin, with William Gyfford and five other EIC employees, to seek the establishment of commercial relations with Tonkin. However, it was not until 14 March 1673 that Gyfford had an opportunity to meet Trịnh Tac. After receiving the gifts and letter of the Bantam Council, the Trịnh lord only allowed the EIC to set up their factory at Phô Hiến, but not at the capital of Tonkin as the EIC mission had hoped.

Even though we cannot be certain that this manuscript was issued by Trịnh Tac, it is still an important historical record as it reflects the fluidity and versatility of commercial and political affairs of the changing world of the mercantilism and the arrival of colonialism in Asia.

Two scrolls of Emperor Cảnh Thịnh (r. 1792–1802)

These two scrolls are important historical documents of the Tây Sơn rulers who governed Vietnam briefly in the late eighteenth century (1772–1802). The first scroll (Or. 14817/A) is written in Hán-Nôm characters on orange paper decorated with a large dragon, and bears the royal seal stamped in red ink. This scroll is in good condition with all of the text still intact. The second scroll (Or. 14817/B), however, is slightly damaged, as can be seen here. Although the day of the month (20) can still be read, the part of the text naming the month and year is missing. However, Trần Nghĩa, a Vietnamese scholar and expert in Hán-Nôm who inspected these two scrolls in 1995, is of the opinion that, considering the content and style of writing, both scrolls were issued at a similar date and for the same occasion.

The content of the first scroll reveals that it was issued by Emperor Cảnh Thịnh on 1 May 1793 to Lord McCartney, the head of the

British diplomatic and commercial mission to China in 1792.

In 1793 the mission was on its way to China to establish commercial relations between Britain and China, when it was struck by a storm off the coast of Central Vietnam. Lord McCartney sent a delegation to the Emperor seeking help and provisions. In return, the Emperor provided rice and other food, and sent this scroll to welcome the mission. The British Library acquired these two manuscripts through purchase in June 1993.

Front and reverse of Vietnamese imperial scroll, 1793. Or. 14817/B.

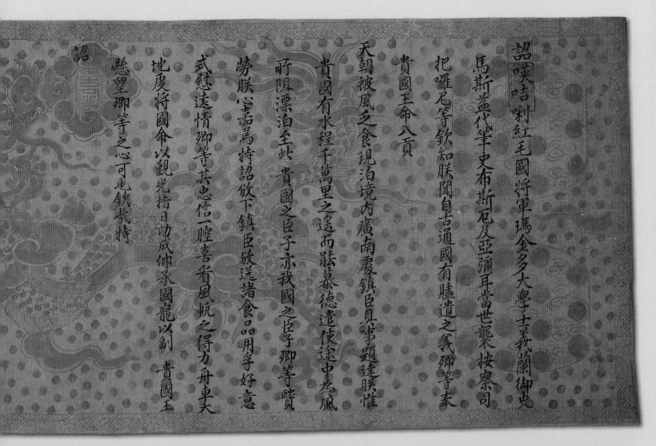

詔嘆咭唎紅毛國將軍瑪金多大學士羲蘭御史

馬斯蓋代筆史布斯厄及亞彌耳當世襲按察司

把囉尼等欽知朕聞自古通國有贐遺之義卿等表

貴國王命八貢

天朝被風之食現泊境內廣南慶鎮臣具事題達朕惟

貴國有水程千萬里之遠而眷慕德遣使途中為風

盹阻漂泊至此　貴國之臣子亦我國之臣子卿等瞻

勞朕心嘉焉特詔放下鎮臣放送諸食品用學好意

武慰遠情卿等其忠信一腔喜肴看風帆之得力舟車夫

地慶將國命以觀光指日功成仰承國寵以副　貴國王

懸望卿等之心可也欽哉特

詔

Three imperial edicts of Emperor Khải Định

Emperor Khải Định (1885–1925, r. 1916–25), who considered Vietnam to be a backward country in need of Western technology, was criticised by the nationalists for his pro-French attitude and extravagant lifestyle. The British Library holds three imperial edicts issued during his reign; all are elaborately decorated.

On the occasion of his enthronement, Khải Định issued an edict dated 18 March 1917 to raise the status of the spirit of Đông Hải of Hậu Bổng village in Hải Dương province (Or. 14631). Đông Hải was upgraded to a mid-rank god (Trung đẳng thần), reflecting the Vietnamese tradition of deification of spirits or gods. These spirits could be nature deities, community or ancestral deities, national heroes or ancestral gods of a specific family, and are classified according to their status. The edict was written on yellow paper, and measures 123 x 51 cm. The front side has a dragon pattern with silver scales and bears an imperial seal. On the reverse, unlike other scrolls in the collection, there are two patterns of flower pots and symbols of longevity instead of the usual four mythical creatures.

On the occasion of his fortieth birthday, Emperor Khải Định issued an edict on 25 July 1924 to honour the spirit of Phạm Công

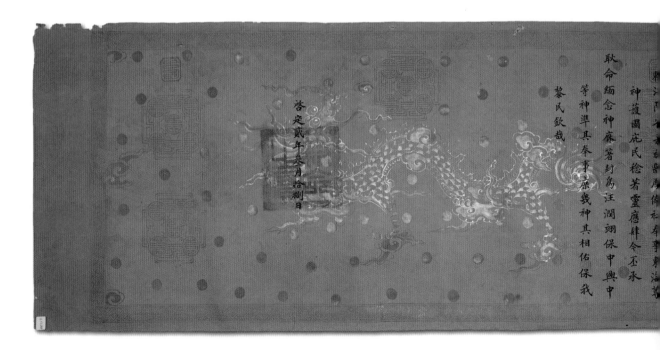

of Văn Lâm village, Hải Dương province (Or. 14632). The edict was written on yellow paper and is finely decorated with different patterns. The main design in the middle of the paper is a gilded dragon and an imperial emblem, and the edict bears an imperial red seal. On the reverse are the four mythical and sacred animals, namely the dragon, phoenix, turtle and unicorn, all beautifully painted with gilded outlines. There are two symbols of longevity in the middle of the scroll, which measures 135 x 52 cm. The Library purchased these two manuscripts in June 1991.

On the same day, Emperor Khải Định issued a further edict (Or. 14665); this one was to raise the status of the spirit of the god Nam Hải of Hậu Bổng village in Hải Dương province (the same deity named in Khải Định's edict of 1917) to the highest rank. He became god of the South Sea. The edict is written on gilded yellow paper in the same fashion as the other edict issued on the same date, with a bold golden dragon design. The reverse was decorated with the four gilded mythical and sacred animals and also two symbols of longevity. The Library acquired this manuscript through purchase in March 1992.

It should be noted that dragon designs differed from one dynasty to another. Nguyễn Ngọc Tho from the University of Social Sciences and Humanities, Vietnam National University, points out that in comparison with the Japanese dragon, the Vietnamese dragon is characterised by three main features: (1) non-standardisation, (2) diversity and (3) constant change and development. For example, the Ly dynasty's dragon (eleventh to thirteenth centuries) was a long snake-like figure without scales and with a zigzag curly body. During the Trần dynasty (1226–1400) the dragon's body became bigger and fatter, the claws became sharper and the head and the neck were irregularly changed, while the dragon's tail remained unchanged. From the Lê dynasty (1428–1527 and 1599–1788) onward, the dragon was greatly influenced by the Chinese exemplar, and therefore local features tended to recede. After 1945, with the end of the last feudal dynasty, the noble significance of the dragon weakened and eventually disappeared.

Imperial edict of Emperor Khải Định,
25 July 1917. Or. 14631.

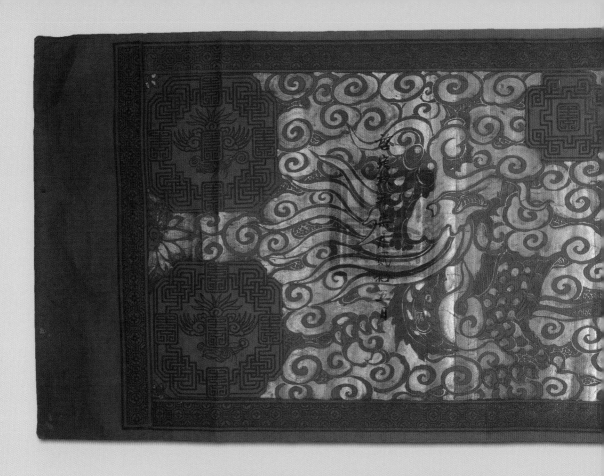

Front of Imperial edict of Emperor
Khải Định, 25 July 1924. Or. 14665.

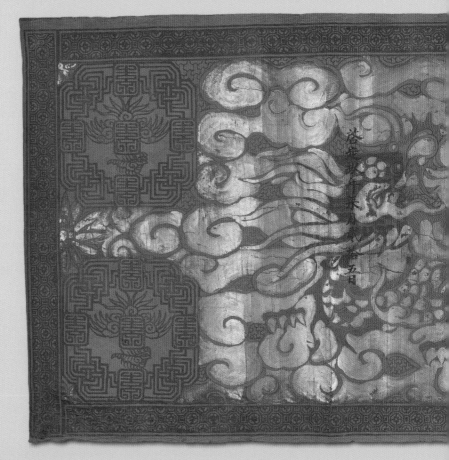

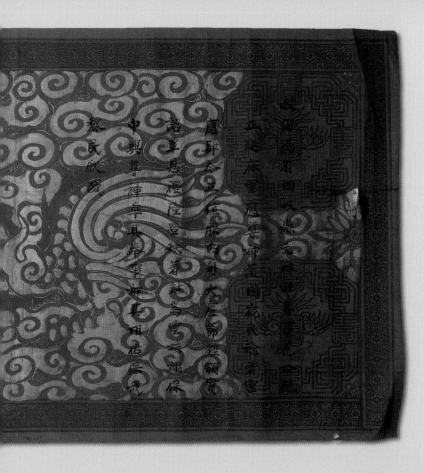

Front of Imperial edict of Emperor
Khải Định, 25 July 1924. Or. 14632.

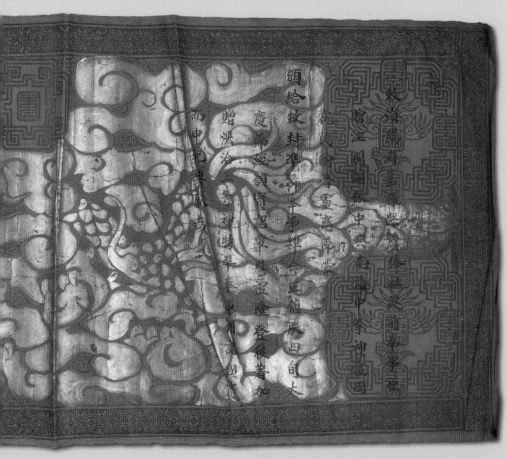

Bound books

The Tale of Kiều

The copy of the *Truyện Kiều* manuscript held at the British Library (Or. 14844) was completed around 1894. It is written in Chữ Nôm (Sino-Vietnamese characters). Each page is beautifully illustrated with scenes from the story. It is bound in a royal yellow silk cover with dragon patterns. Nguyễn Quang Tuân, an independent Vietnamese scholar who inspected the manuscript, is of the opinion that this manuscript bears some royal significance because the dragon on the cover has the five claws, a characteristic normally reserved for imperial use only. Another significant feature of this manuscript is that it bears annotations by Paul Pelliot (1878–1945), the renowned French Sinologist, who bought the manuscript in 1929.

By 2015 the manuscript was in poor condition; in particular its very thin paper had become brittle and was torn in places due to acidity and wear and tear. Fortunately, the conservation team at the British Library was able to fully restore this invaluable manuscript to its former glory. It has also now been fully digitised and the reader is able to closely appreciate the artistic beauty of the drawings through the digitised version.

Opposite: Thúy Kiều with Thúy Văn and Vương Quan, her younger sister and brother, on their way to visit ancestors' graves (Paul Pelliot's annotations can also be seen at the top left of the folio). Or. 14844, f. 1r.

Anno 1894

金雲翹繪本

金雲翹新傳

55

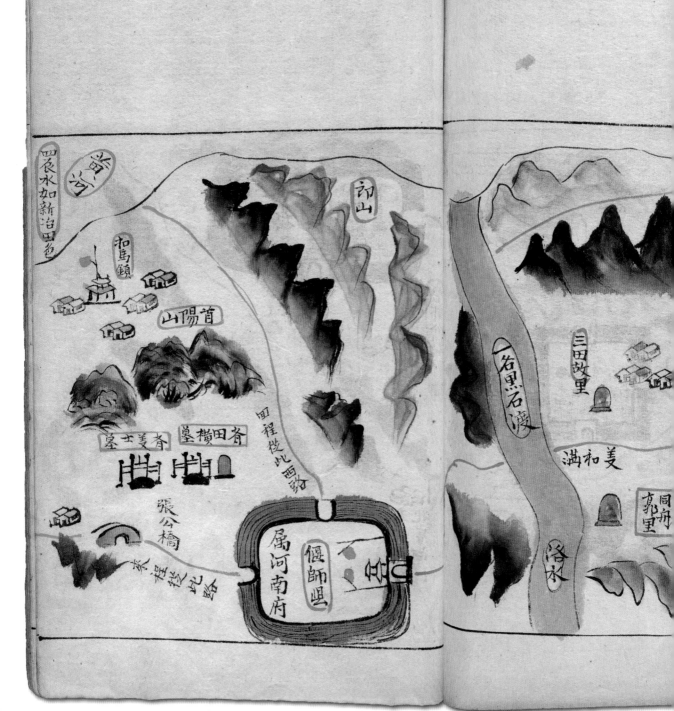

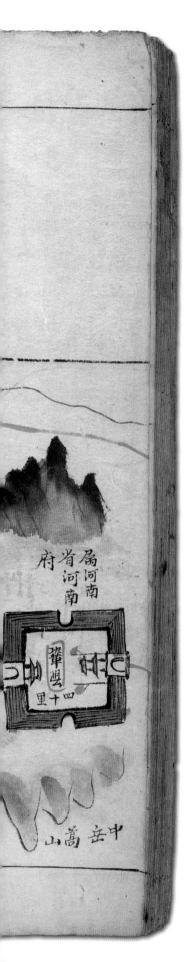

A rare Vietnamese map of China

One of the most interesting Vietnamese manuscripts in the British Library is *Bắc Sứ Thủy Lục Địa Đô* or, in Chinese, *Beishi shuilu ditu* ('The northwards embassy by land and water from Hanoi to Beijing'). Written in the Vietnamese language in Chinese characters (*chữ Hán*) and dated 1880, the manuscript is a complete visual record of the route from Bắc Thành (the former name of Hanoi under the Nguyễn dynasty) through China to Beijing, taken by envoys of the Vietnamese Emperor Tự Đức (r. 1847–83) on their tribute-bearing mission in 1880. This work was probably created as an archival record of the journey. Roads, mountains, waterways, bridges, buildings, cities and towns are all clearly depicted, as are the points of departure and arrival on the first and last pages. The title, written in Chinese characters (*Beishi shuilu ditu*), also includes the date (*gengchen*) of the journey, according to the Chinese sixty-year cyclical system. The annotations on each page list place names and distances in Chinese miles (*li* or *ly* in Vietnamese) with occasional useful notes, such as 'from here merchants used only Qianlong money'. Land routes are marked in red ink and water routes are recorded in blue ink.

Towards the end of the nineteenth century Vietnam faced serious threats from French colonialism. After taking South Vietnam (Cochin China) in the 1860s, the French gradually fulfilled their territorial desire to occupy the rest of the kingdom. In January 1874, after another defeat, the court of Emperor Tự Đức had to sign a treaty with the French which led to the

The mission passed through Gong Xian County in Henan Province and crossed Luo River.
Or. 14907, ff. 54v–55r.

occupation of North Vietnam. Under this treaty, Vietnam's foreign policy was under the control of the French colonial power. However, Vietnam still kept up its tradition of sending tribute missions to China.

The tribute system was employed in Chinese foreign policy for many centuries before its collapse at the end of the nineteenth century under the Qing dynasty. As the most powerful kingdom in East and South East Asia, China saw itself as 'the Middle Kingdom' and demanded that smaller and 'inferior' kingdoms in the region send tribute on a regular basis. Small states in the region willingly sent tribute missions to Beijing, while not viewing this tradition as acknowledgement of vassalage to China; on the contrary, it was perceived as a reciprocal system, whereby Beijing was accepted as the patriarch of other, inferior kingdoms. Once their missions had been received by the court in Beijing, recognition by China gave rulers of smaller kingdoms legitimacy to rule. The tribute system also provided security and political stability for smaller kingdoms against invasions from China so long as they did not implement any policy that would disturb the Middle Kingdom.

As one of China's neighbouring countries, Vietnam had been one of the most active participants in the tribute system, which offered political gains including peaceful co-existence with its powerful neighbour. As the political scientist Brantly Womack points out, China was always Vietnam's greatest political threat – so Chinese recognition of the Vietnamese court as the legitimate rulers of the country was invaluable and was tantamount to an acknowledgement of Vietnam's right to exist. In contrast to the colonialism of Western imperialism, China acted as the passive guarantor of a matrix of unequal but autonomous relationships, rather than as an active metropolitan power: to go to Beijing was more reassuring than to have Paris come to you.

Opposite: Arriving at Ansu Xian County in Hebei Province, north of the Yellow River, the route took the Vietnamese embassy through temples and the White Pagoda. Or. 14907, f. 66r.

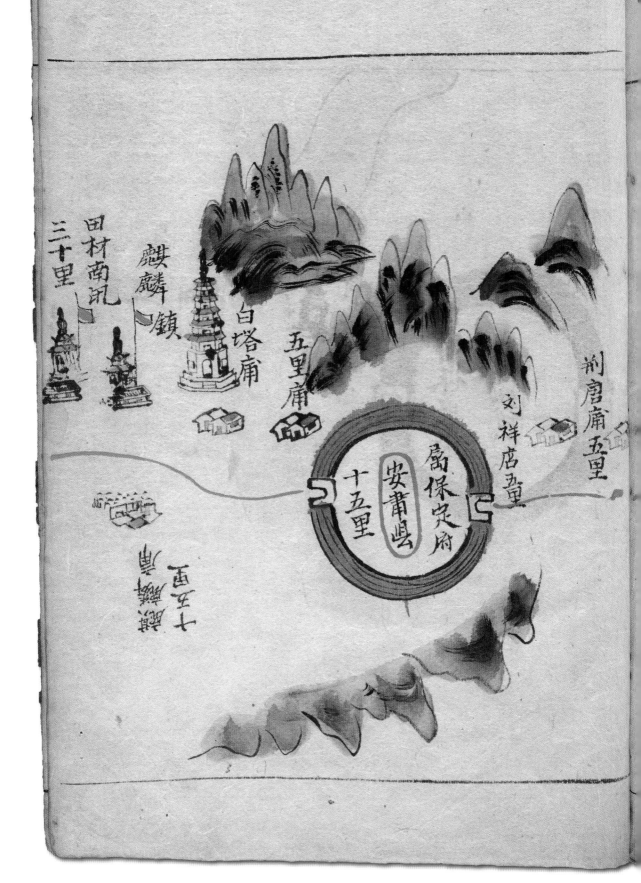

田村南汛三十里

麒麟鎮

白塔廟

五里廟

劉祥店五里

荊唐廟五里

屬保定府

安肅縣十五里

西五十

Zhengyang Gate, Beijing, leading to the Forbidden City. Or. 14907, f. 69v.

From its very beginnings, not only did independent Vietnam publicly accept its status as a vassal, but it also sent its most prominent scholars as emissaries on tribute missions. The historian William Duiker has characterised the historical relationship between China and Vietnam as follows:

To China, the Vietnamese must have resembled a wayward younger brother ... Chinese attitudes toward Vietnam combined paternalism and benevolence with a healthy dose of arrogance and cultural condescension stemming from the conviction that it was China that had lifted the Vietnamese from their previous state of barbarism. As for the Vietnamese, their attitude toward China was a unique blend of respect and truculence, combining

a pragmatic acceptance of Chinese power and influence with a dogged defence of Vietnamese independence and distinctiveness.

The 1880 tribute mission took place against a backdrop of political difficulties in Vietnam. After the signing of the 1874 treaty, there was unrest in North Vietnam (Tonkin) among Vietnamese who saw the Nguyễn rulers as weak leaders who had readily capitulated to French power. The Black Flag rebellion, led by Lưu Vinh Phục, caused disruption to foreign businesses and French religious missions, disturbing both Beijing and Paris. Hence two Chinese incursions took place in 1878 and 1879, while at the same time, the French kept putting pressure on the court in Huế with the threat of another invasion. In order to appease the Chinese and to seek help from the Middle Kingdom, the Vietnamese court tried to send missions to Beijing. Some were successful, but others were intercepted by the French. The 1880 tribute mission was therefore one of several attempts. It probably crossed the border in early October and arrived in Beijing in December 1880.

The French perceived the Vietnamese court's attempt to seek help from China as a violation of the 1874 treaty, which stipulated that Vietnam's foreign affairs were under French authority. The colonial power thus used this as one of the pretexts to launch another attack against the Vietnamese. In April 1882, French forces attacked Hanoi and subsequently Huế. Emperor Tự Đức died on 17 July 1883, just before the court agreed to sign another treaty with the French (25 August 1883), which brought all three parts of Vietnam under the complete control of the French colonial government.

The advent of French control over Vietnam seriously affected Chinese interests because trade between southern China and northern Vietnam was disrupted. Therefore, from 1882 China sent troops to northern Vietnam to protect its interests, and fighting between French and Chinese forces erupted. However, the weakening Qing dynasty was not able to match the French might. The confrontation ended with the Tientsin Agreement in May 1884, in which China agreed to rescind its claims over Vietnam's sovereignty. This also brought an end to the long-lasting tradition of the tribute system between China and Vietnam.

Vietnamese theatre

Traditional Vietnamese theatre can be divided into two main genres: *chèo* and *tuồng* or *hát bội*. *Chèo* is probably the oldest form of Vietnamese theatrical performance and can be dated back to the tenth century. It is believed that it originated from a boating song performed at popular festivals, hence the name *chèo* or 'song of oars'. This traditional performance was popular in the north of Vietnam and was closely associated with peasants or commoners because of the simple and basic way it was performed. Initially, it did not even require a stage, and the artists simply wore their everyday clothes. There were no written texts, and the accompanying songs were closely related to folk songs. This form of performance was meant to be a funny and light-hearted entertainment.

If *chèo* was originally a popular entertainment for peasants, *tuồng* (in the North) or *hát bội* (in the South) stood traditionally at the other end of the performance genre. *Tuồng*, which could be translated as 'classical theatre', was believed to have originated in a royal court of the Trần dynasty (1225–1400 AD). Most scholars agree that there was a Chinese impulse to the birth of Vietnamese classical theatre. Legend has it that in 1285, a Chinese opera troupe was captured during a Vietnamese military campaign against the invading Mongols. Emperor Trần Nhân Tông (r. 1279–93), the third emperor of the Trần dynasty, was so impressed by the operatic and theatrical knowledge of the captives that he had the leader of the troupe train young Vietnamese in the performing art in exchange for his life. Under the patronage of subsequent emperors, *tuồng* developed to suit Vietnamese taste, and new plays were written, some based on Vietnamese, rather than Chinese, history. In the sixteenth century *tuồng* spread to the South and by the eighteenth century it was popular throughout the country and among all classes, from emperors to peasants.

Tuồng reached its apogee under the Nguyễn dynasty (1802–1945). Emperors and high-ranking mandarins became patrons of

Chiếu chèo. Tranh Phạm Trí Tuệ giấy dó –
1992.

Chiếu chèo, a very basic play performed on a mat. Sân Khấu, Hanoi:
Báo Quân Đội, no. 184 (August 1996), p. 42. 16671.c.4.

troupes and had performances given in their private chambers. The first special theatre was built in the imperial palace of Emperor Gia Long (r. 1802–20). Emperor Tự Đức (r. 1847–83) encouraged court poets to write opera, and he brought into his court the Chinese actor Kang Koung Heou and maintained 150 female performers. During the Nguyễn dynasty, *tuồng* was very similar to Beijing opera in terms of costumes, stagecraft and make-up.

It was under these conditions that a large number of *tuồng* playscripts were created, written in *Hán-Nôm* (Sino-Vietnamese script) or *Hán* (Chinese script). One scholar reports that in Vietnam today there are still four to five hundred compositions, some of which run to as many as a dozen volumes. Most traditional *tuồng* are based on Chinese history or literary works, but there are others that dramatise events in Vietnamese history or literature. Themes include struggles at court between an evil courtier and the emperor, loyalty, filial piety and the virtues of patriotism.

Sadly, *tuồng* declined in the twentieth century because it lost the patronage of the royal court. Former glamorous court performers had to earn their living by travelling around with their troupes and performing wherever people were willing to pay them. However, the decline in court performances eventually led to a new genre of theatre known as *cải lương*, which was an adaptation of this classical performance.

A ten-volume set of *tuồng* plays (Or. 8218) held in the British Library is very likely to be the product of the popularity of this performing art form in the mid-nineteenth century under the Nguyễn dynasty. It comprises a collection of forty-six plays and legends, possibly from Huế, the capital of Vietnam during the Nguyễn dynasty. Most do not include the author's name, date and place except for one piece, *Sự tích ra tuồng*, which has a line that could be translated into modern Vietnamese as '*làm vào ngày tháng tốt năm Tự Đức 3*'. According to Trần Nghĩa (a Vietnamese specialist in *Hán-Nôm* who researched the manuscripts at the British Library back in 1995), this note indicates that the play was written in 1850 during the reign of Emperor Tự Đức (1847–83).

The complete ten-volume set of manuscripts, containing over 6,800 pages, has been now fully digitised thanks to the legacy of

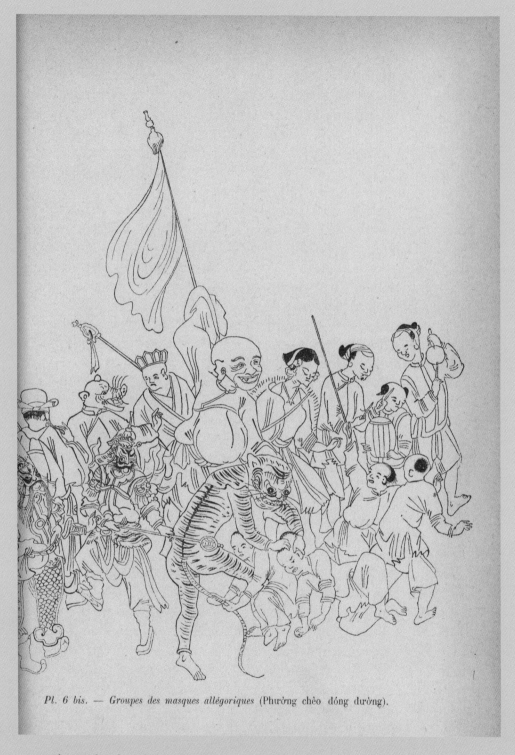

Pl. 6 bis. — Groupes des masques allégoriques (Phường chèo dóng dường).

Phường chèo dóng dường: *chèo* performed at a funeral. Gustave Dumoutier, *Le Rituel Funéraire des Annamites*. Hanoi: F. H. Schneider, 1904; plate 6 bis. 11100.f.22.

Henry Ginsburg. Henry Ginsburg, former curator for Thai, Lao and Cambodian at the British Library, passed away prematurely in 2007. A generous bequest from Henry Ginsburg's Estate has enabled the digitisation of many Southeast Asian manuscripts in the British Library, including all the complete collection of Vietnamese manuscripts.

Title page of the first play in the manuscript,
Tống Tử Minh truyện. Or. 8218, vol. 1, f. 1r.

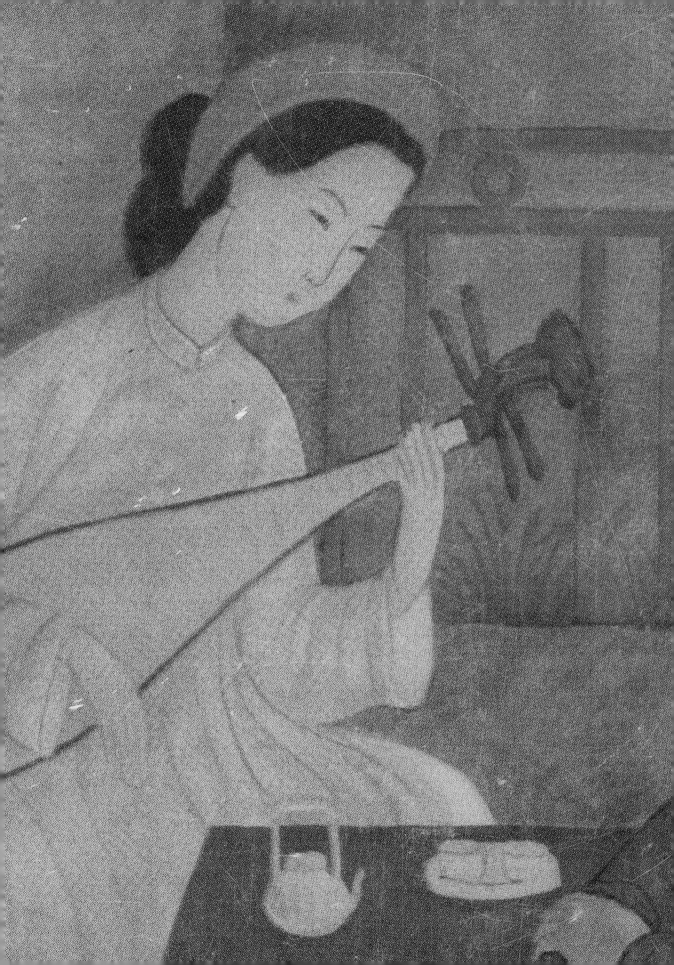

Fifty shades of Kiều

Kim Văn Kiều, or the *Tale of Kiều*, by Nguyễn Du (1765–1820), is a jewel in the crown of Vietnamese classical writing. Its original title in Vietnamese is *Đoạn Trường Tân Thanh* (*A New Cry from a Broken Heart*). However, it is better known as *Truyện Kiều* or *Kim Văn Kiều*. In Vietnam, the *Tale of Kiều* has been embraced by the general public, who see it as a romance, a book of divination and a moral fable, while scholars explore its literary, linguistic, philosophical, political and social aspects. The eponymous heroine is the most acclaimed woman in Vietnamese literature, and her captivating but tragic story has inspired many artistic depictions. The most outstanding version in the British Library collection is undoubtedly a manuscript that was completed around 1894, written in Hán-Nôm with illustrations of scenes from the story on each page, and a fine yellow silk binding with dragon patterns. Shown here are a selection of images of Kiều from this beautiful manuscript, alongside more recent portrayals from printed books.

Literary critics have argued that the theme of the story is an allegory of Nguyễn Du's guilt and conflict of interest in agreeing to work for the new regime (the Nguyễn dynasty, 1802–1945), which had been indirectly involved in the overthrow of his former master. This behaviour was unacceptable in traditional Confucian Vietnamese society as it was tantamount to betraying filial piety. Hence the theme of the story was a poignant reminder for Nguyễn Du, who was born into a high-profile mandarin family, and whose father served as a high-ranking minister under the Lê dynasty (1428–1788).

Nguyễn Du was inspired by a Chinese Qing dynasty novel, The *Tale of Chin, Yu, Ch'ia*, while he was leading a diplomatic mission to Beijing in 1813. He rewrote the story by using *lục-bát* or 'six-eight' verse form. The *lục-bát* was a commonly used and popular style in folk poetry and it was conducive to reciting; its name refers to the alternating lines of six and eight syllables.

低呐翠翔欣翠雲計色辰花柳群輪計

才辰覩琴棋詩書麻春樽皮課胲貐寔

罡風流閟静

翾強色稍漫漉

瀾秋水湮春山

浟堆迎渚迎城

聰明本産性孟

宮商漏塙五音

曲茄珊搨臧張

風流室墨紅裙

淹祢帳捻慢愛

揚才色吏罡分欣

花悮輸襦柳憒歆樽

色傳隊浟才傳和臼

坡芸詩書覘味歌吟

芸穢唉担胡琴浟張

浟窝落命吏強惱人

春樽執齒細句及箏

墻東蜂蛇彭衕杰埃

秋水為神春山如笑

韓愈詩惟解醉紅裙

芙蓉如面柳如眉翾之穠色花柳更不

如也

李延年侍上歌北方有佳人絕世而獨

立一顧傾人城再顧傾人國亦知傾城

與傾國佳人難再得

天寳遺事楚連香国色出則蜂蝶相隨。

礼女子十五許嫁筓而字

The title *Kim Vân Kiều* derives from the names of three important characters: Kim Trọng, Kiều's fiancé and her first love; Thúy Vân, Kiều's younger sister; and the protagonist, Thúy Kiều herself. Arguably the most recognised and stereotypical image of Kiều is of her playing a musical instrument, usually depicted either as a *ho* guitar or a *p'i p'a* lute. In his English translation of the story, Lê Xuân Thủy describes her talents and beauty:

> The bow of her eyes looked like two graceful autumn waves ... flowers envied her brightness, and willow shivered for not being so clear. With one sidelong glance, then another, she could subvert empires and put cities in revolution ... Being a thorough master of the *Cung Thương* five-tone scale, she excelled chiefly in playing *ho* guitar.

(Lê Xuân Thủy, [1966?], pp. 176–77)

Kiều was born to a family of scholars and was a vision of idealised, virtuous Confucian womanhood: beautiful, chaste, obedient and loyal to her family. Her fate was doomed, however, and she had to sacrifice her love and life to save her father and her family. After a noble upbringing, she gradually fell into disgrace, being forced to work as a prostitute, not once but twice, and had four husbands. At one point she even stole valuables from her master to survive. After fifteen years of suffering, she was finally reunited with her first love, Kim Trọng. After all she had gone through she could not see herself as his wife, and therefore remained in a platonic relationship with him, and asked her younger sister, Thúy Vân, to marry him instead.

It is hard to imagine how this pure and talented young lady faced and coped with her subsequent downfall. In the following images, the manuscript artist depicts the lowest point in Kiều's life, when she was sold by her first husband to a brothel. Tứ Bà, the madam and owner of the brothel, cajoled Kiều into prostitution:

Opposite: Kiều demonstrates her talent for playing the *ho* guitar.
Or. 14844, f. 3r.

'Listen to this my daughter, and keep this in mind: there are seven interior attitudes and eight intimate techniques to amuse people ... until you can turn them upside down like stones ... you must know how to charm them, sometimes by the tips of your lips, sometimes by the corner of your eyes, sometimes by reciting alluring poems, and occasionally by the flowers of your smile.'

As the literary critic Nathalie Huynh Chau Nguyen points out, Kiều and this literary genre 'stand out as a character of universal

Above: Kiều meets Kim Trọng for the first time. Or. 14844, f. 6r.

Opposite, above: Tứ Bà teaches Kiều how to use her charms to attract men. Or. 14844, f. 29v.

Opposite, below: Kiều is kidnapped on the order of Hoạn Thư, the first wife of Kiều's second husband. Or. 14844, f. 38v.

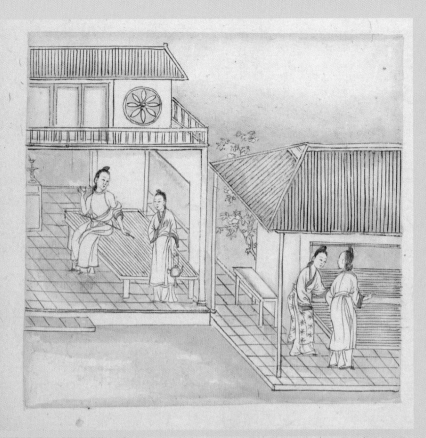

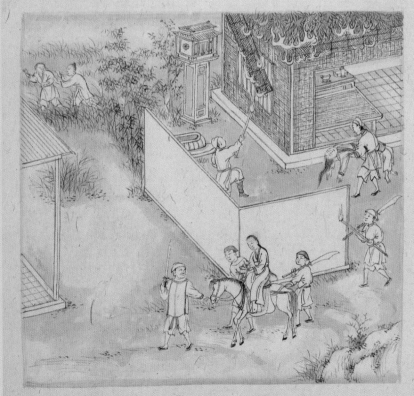

Kim Vân Kiều, English translation by Lê Xuân Thủy (1960?). 16690.a.40, front cover.

and enduring appeal, a vulnerable individual with whom those most acutely affected by change and misfortune can readily identify. For generations of Vietnamese who have experienced years of turmoil, changing regimes, colonisation, post-colonisation, war and exile, Kiều's troubles strike a deep emotional chord.'

Reflecting its popularity, *Kim Văn Kiều* has been widely published in various forms, and in the British Library alone there are more than thirty books on this Vietnamese classic. Literary criticism, different interpretations and translations of *Kiều*, both in Vietnamese and foreign languages, continue to be published; for instance, in 2004 Vladislav Zhukov translated the story into English with his own interpretations. His version complements other widely recognised English translations, especially those by Lê Xuân Thủy in the early 1960s and by Huỳnh Sanh Thông in 1973.

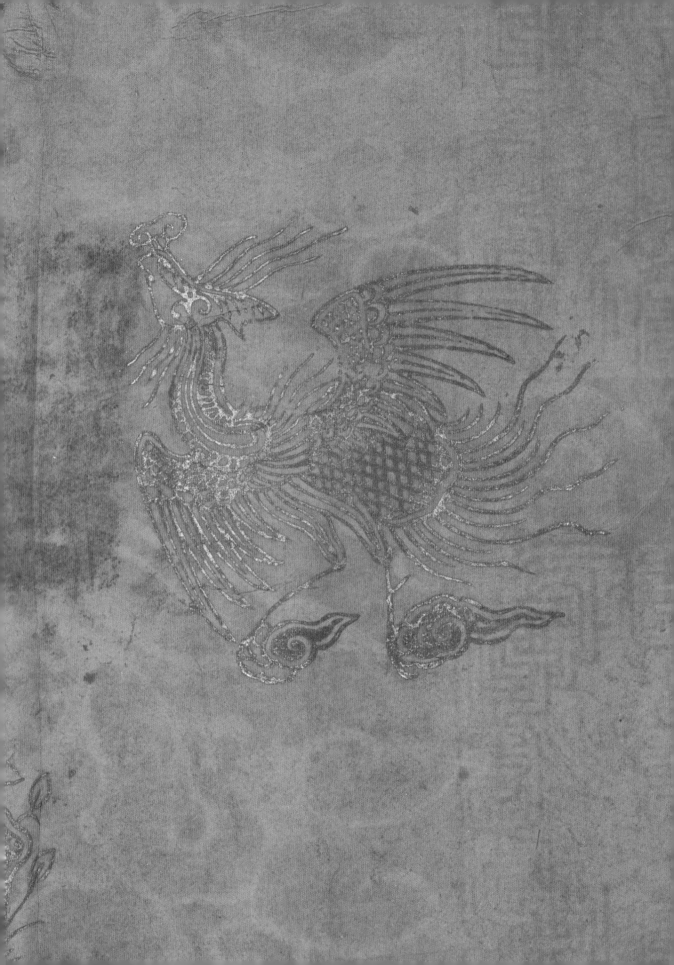

Mythical creatures in Vietnamese culture

Like other East and South East Asian peoples, the Vietnamese believe in mythical and sacred animals, the most significant being the dragon, the phoenix, the turtle or tortoise and the unicorn. These four sacred animals, which all represent auspicious blessings such as longevity and happiness, can be found on various objects in Vietnam ranging from imperial edicts and paintings, decorative figures in palaces and temples, to clothes and utensils. The four sacred animals illustrated here are depicted on different imperial Vietnamese illuminated scrolls held in the British Library.

Dragon (rồng)

The Vietnamese believe they are descendants of a dragon, and the birth of the first Vietnamese kingdom was closely related to this animal; therefore this mythical creature is probably the most important figure among the four sacred creatures. Legend has it that Lạc Long Quân, king of the dragons who lived in the water, married Âu Cơ, a fairy from the bird kingdom. She gave birth to 100 sons and the first-born son became King Hùng Vương of Lạc Việt, the first dynasty of Vietnam. Hence there is a proverb saying the Vietnamese are *con rồng cháu tiên* or 'children of the dragon and grandchildren of the fairy'.

To the Vietnamese, the dragon symbolises power, nobility and immortality. Since it represents power, it is a special symbol of the Vietnamese emperors. The dragon with five claws was reserved for imperial use, while one with four claws was for the use of royal dignitaries and high-ranking court officials. Dragons for commoners could only have three claws.

The Vietnamese dragon combines features of the crocodile, snake, cat, rat and bird. There are many Vietnamese legends or

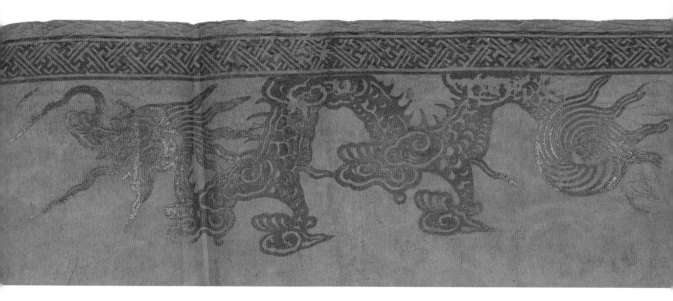

Detail of dragon on Emperor Khải Định's scroll, 1924. Or. 14665.

tales which are related to dragons; for example, the world-famous natural heritage site, Hạ Long Bay in northern Vietnam, is believed to be a creation of a dragon. Thăng Long, the former name of Hanoi, also means 'rising from a dragon'. Legend has it that in 1010, a golden dragon appeared alongside Emperor Lý Thái Tổ's boat while he was visiting Đại La, and hence the place's name was changed to Thăng Long.

Phoenix (phượng hoàng)

Whereas the dragon represents the emperor, a phoenix is used to represent the empress. Vietnamese folklore describes the phoenix as having the neck of a snake, the breast of a swallow, the back of a tortoise and the tail of a fish. The phoenix's song includes all the five notes of the pentatonic musical scale and its feathers include the five fundamental colours: black, white, red, green and yellow. This elegant mythical bird symbolises grace, nobility, virtue and pride. According to myth, the phoenix burnt its nest and days later rose again from the ashes, and it therefore symbolises rebirth, regeneration and survival. It normally hides itself in time

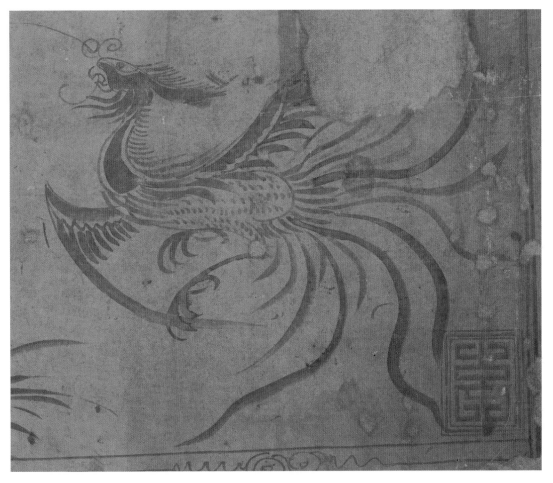

Phoenix, illuminated on the reverse of Emperor Cảnh Thịnh's scroll, 1793 Or. 14817/B

of trouble and appears only in calm and prosperous times; hence it also symbolises peace. During the Vietnam War, the CIA launched Operation Phoenix in South Vietnam from 1968 to 1972, with the aim of eradicating the Việt Công.

Turtle (rùa)

The turtle has a special place in Vietnamese culture and history. It symbolises longevity, strength and intelligence and is also closely related to the independence of Vietnam in the fifteenth century. Legend has it that Lê Lời, who led the Vietnamese to fight against

the Chinese invaders in 1428, borrowed a sword from the dragon king. After he defeated the Chinese, he returned the sacred sword to the king via the latter's disciple, a turtle which lived in a jade water lake. The Vietnamese, especially Hanoians, believe that this lake is the Hoàn Kiếm Lake (Returned or Restored Sword Lake) in the middle of the city. Until recently, there was a highly revered resident, an old soft-shell turtle, named locally as Cụ Rùa (Grandfather Turtle) living in the lake. Cụ Rùa, who was actually female, was one of only four turtles of this breed known to survive in the world and it was believed that she was over a hundred years old. On 19 January 2016, her lifeless body was found floating in the lake. The cause of her death is unknown and some Vietnamese have interpreted it as an inauspicious omen.

At the Temple of Literature (Văn Miếu) in Hanoi, there are eighty-two figures of stone turtles with steles of doctoral graduates on the turtles' backs. This was a mark of honour for those who achieved the highest degree of education in traditional Vietnamese society during the Lê dynasty. It also signified the importance of education in the society.

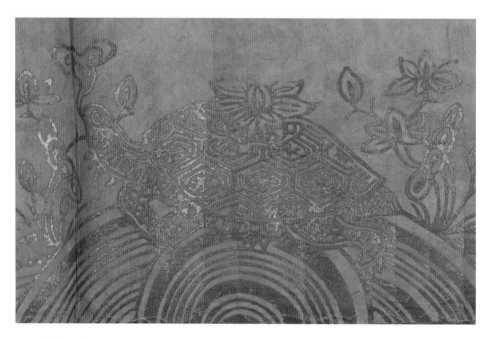

Detail of turtle, illuminated on the reverse of Emperor Khải Định's scroll, 1924. Or. 14665.

Unicorn (Kỳ lân)

The unicorn symbolises peace, mercy and good fortune. Some also believe that it represents intelligence and goodness, and that the creature only appears on very special occasions. The unicorn is a composite creature combining elements of the horse, buffalo and dragon. The Vietnamese believe that it is a very strong and faithful creature, and therefore suitable for guarding temples and places of worship.

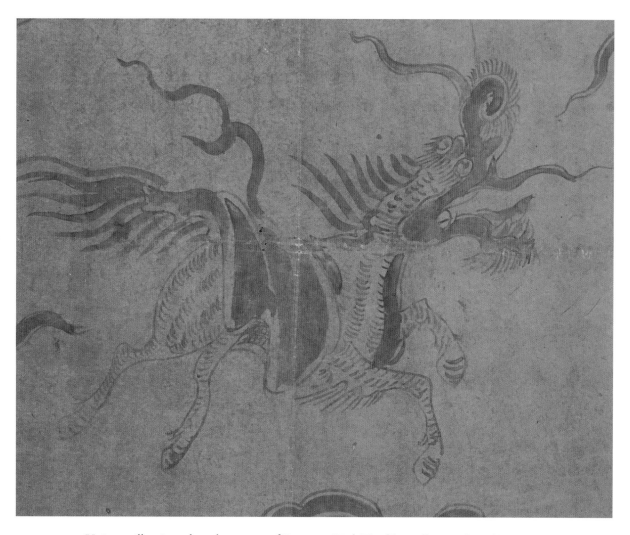

Unicorn, illuminated on the reverse of Emperor Cảnh Thịnh's scroll, 1793 Or. 14817/B

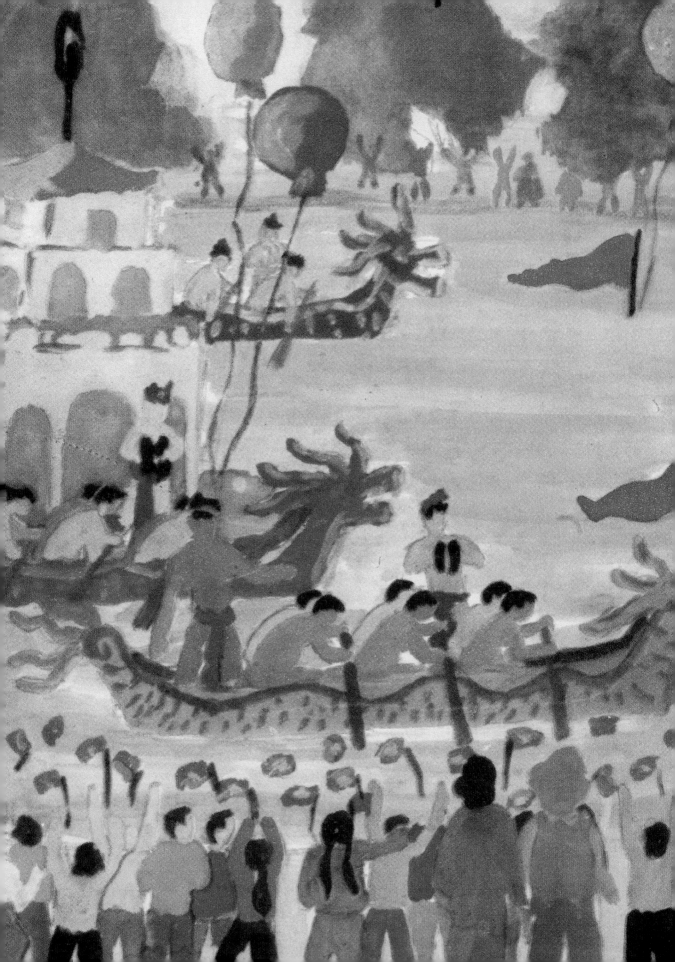

Vietnam and dragons

In Vietnamese culture, as in many other East and South East Asian societies, the dragon plays a very prominent role. It is arguably the most sacred of the four mythical creatures discussed above.

From the very birth of the country, the dragon has been closely associated with Vietnamese kings or rulers, but it is believed that in even earlier times the dragon was used as a symbol at clan level to represent talent, noble and beauty. There are proverbs which refer to the dragon in this context, such as *chữ viết đẹp như rồng bay phượng múa*, 'handwriting is as beautiful as a flying dragon and a dancing phoenix'. The increasing use of the word 'dragon' and objects with dragon patterns by feudal lords led to this creature becoming a symbol of the authority of the imperial clan. In China, it is believed that an emperor of the Han dynasty (206 BC–AD 220) was the first ruler to use the dragon to represent his authority.

Vietnamese tales and legends also reinforce a close association between this creature and the country's rulers. For example, when Lý Công Uẩn took power from the Early Lê dynasty in 1009, he is said to have seen a golden dragon descending from the sky over Đại La citadel. He therefore renamed Đại La as Thăng Long ('Rising Dragon'). Lý Công Uẩn became Emperor Lý Thái Tổ, the founder of the Lý dynasty (1009–1225) and Thăng Long, which later became Hanoi, was chosen as the capital. It is believed that both the new emperor and the capital city were blessed by this mythical creature right from the very beginning. Lý Thái Tổ was not the only emperor who claimed to see a golden dragon during his reign, for Emperor Lý Nhân Tông (r. 1072–1128) and Emperor Lê Thanh Tông (r. 1460–97) were also said to have seen golden dragons several times during their reigns.

The dragon is regarded as immortal and even though its appearance can seem frightening, it does not represent evil. On the contrary, in Vietnam the dragon was always regarded as a symbol of power and nobility, and thus became the chief attribute of the

person highest in nobility and greatest in power: the emperor or king. The Vietnamese imperial throne is called *bệ rồng* or 'dragon throne', while the throne hall in the palace where the emperor granted public audiences or worked, such as that in the former imperial capital city of Huế, was also decorated with dragons. Imperial attire and accessories were also related to the dragon; for example, the imperial gown was called a *long bào* and his hat was called a *long quân*.

The shape of the land of Vietnam, which resembles a letter S, also enhances the dragon myth. The Vietnamese consider the shape of their homeland to be similar to a winding dragon: the northern part is its tail, central Vietnam is its body with the *Trường Sơn* mountain range (the Annamite range) as its back and spine, and the dragon's head lies in the southern part, with its open mouth

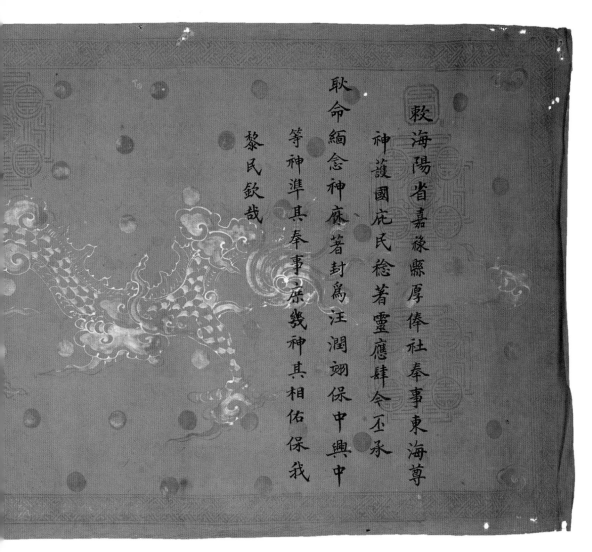

敕海陽省嘉祿縣厚俸社奉事東海尊神護國庇民稔著靈應肆令丕承耿命緬念神庥著封爲汪潤翊保中興中等神準其奉事庶幾神其相佑保我黎民欽哉

Dragon on an Imperial edict of Emperor Khải Định's scroll, 1917. Or. 14631

spraying water into the South China Sea. It should be noted that when the Mekong River reaches the south of Vietnam and branches into nine tributaries in the Mekong River Delta, it is called *Sông Cửu Long* or the 'Nine Dragon River'.

Dragons also appear in many other aspects of Vietnamese life and culture. On auspicious occasions such as the Vietnamese New Year, a dragon dance will be organised. The Nguyễn dynasty (1802–1945) also declared the Dragon Boat Day, originating from Chinese traditions, as one of the 'three great holidays' in Vietnam along with the lunar New Year (*Tết Nguyên Đán*) and the emperor's birthday. The boat race festival was celebrated on the fifth day of the fifth lunar month by peasants in South China and Vietnam, to ward off

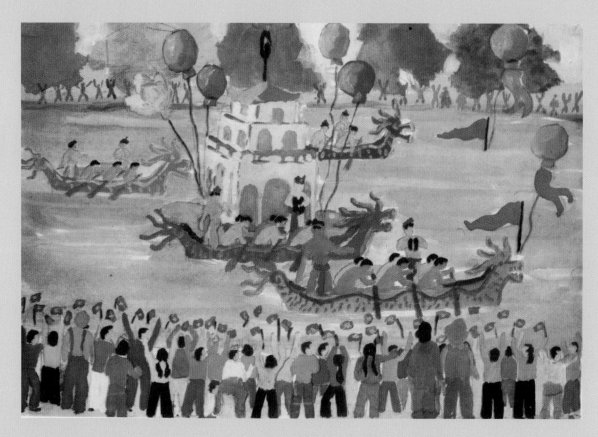

Dragon boat race, *Thiếu nhi vẽ*. Hanoi: Văn hóa, 1977, p. 21. SEA.1986.a.4004.

poisonous spirits. Many Vietnamese proverbs and children's plays relate to dragons, and many place names in Vietnam also contain the word 'Long', or 'Dragon'.

In Ho Chi Minh City (formerly Saigon), there is an historic building called *Nhà Rồng*, or the Dragon House, located at the old port. The house was built by the French in 1862–3 in a French colonial style, but on the rooftop there were two symmetrical ceramic dragons facing each other and looking at the moon, hence the name *Nhà Rồng*. It was from here that the young Ho Chi Minh embarked on a ship to sail to France in June 1911, on his search to find methods to fight French colonialism and seek independence for his motherland. Symbolically, dragons seem to appear at some critical junctures in Vietnamese history.

สัพะ พจะนะ พ

DICTIONARIUM

SIVE S[...]

INTERPRETATIONE LA[...]

[...]TOR[...]

Early dictionaries of South East Asian languages

The expansion of European power in the sixteenth century made South East Asia one of the prime destinations for European adventurers, including not only merchants but also Christian missionaries. Profits from overseas trade in exotic goods from this region, such as spices and forest products, attracted European traders to South East Asia, long before commercial activity spiralled and became an integral component of Western colonialism. The desire to convert local people to Christianity also brought priests into various parts of South East Asia from the early sixteenth century.

Western missionaries, diplomats and traders all needed to be able to communicate with the indigenous populations, and dictionaries were essential tools in facilitating their work. In 1522 Antonio Pigafetta, an Italian who joined Magellan's circumnavigation of the globe, compiled a word-list of Malay with more than 400 entries. In 1651, the *Dictionarium Annamiticum Lusitanum et Latinum*, a trilingual Vietnamese–Portuguese–Latin dictionary compiled by Alexandre de Rhodes, was published in Rome for religious purposes. This work contributed tremendously not only to the development of dictionaries in Vietnamese but also to the use of Romanised script for the Vietnamese language (*Quốc Ngữ* or national language). Rhodes was a French Jesuit priest and lexicographer who was sent to Vietnam in 1619. His dictionary was later used in the development of a Vietnamese–Latin dictionary compiled by another French missionary, Pigneau de Béhaine, in 1783. The latter work was revised by Jean-Louis Taberd and was published as a Chinese–Vietnamese–Latin dictionary in 1838.

On 30 March 1795, the Institut National des Langues et Civilisations Orientales (National Institute of Oriental Languages and Civilisations) was founded in Paris, with a mission to teach living Oriental languages 'of recognised utility for politics and commerce'.

The British and the Dutch were engaged in similar academic activities, and various centres for research and scholarship in 'Oriental Studies' were founded in London, Leiden and elsewhere. In July 1800, Fort William College was established in Calcutta. Founded by Lord Wellesley, the Governor-General of British India, it emerged as a research and publication centre with a primary aim of training British civilians in the languages and cultures of India. The College published thousands of books in English, translated from major languages of the subcontinent, including dictionaries of Bengali, Hindustani and Sanskrit.

In Britain, the London Oriental Institution was co-founded by John Borthwick Gilchrist and the East India Company in 1805, primarily as a college to teach Indian languages to civil servants. Gilchrist had been the first professor of Hindustani at Fort William College in Calcutta. However, as British interests were not only limited to India but also included South East Asia, the Council of the Fort William College also recommended that the government of India should compile a similar work in the major languages of mainland and maritime South East Asia (then vaguely named collectively as the nations in the Eastern isles, between India and China). Hence the *Comparative Vocabulary of the Barma, Maláyu and Thái Languages* by Dr John Leyden was published in 1810.

The *Comparative Vocabulary* has 3,166 entries in Burmese, Malay in Jawi script, Thai in Romanised script and English. The entries were not listed in alphabetical order but arranged by topic, such as God, nature, the elements, diseases, trades, commerce, ships, armies and warfare, and government. In the 1830s Eliza Grew Jones, a Baptist missionary who travelled to Burma and Siam, compiled a word-list of about 8,000 Thai–English words, phrases and terms. Her original manuscript has since disappeared, but in 1839 the Rev. Samuel P. Robin had made a copy of her work, and this manuscript dictionary is held in the Widener Library, Harvard University.

Printing in Thai script in Thailand only began in 1835, when an American Protestant missionary, Dr Dan Beach Bradley (1804–1873), brought a Thai script printing press from Singapore to the kingdom. This made it possible to publish Thai and multilingual dictionaries, the first appearing in 1854. It was compiled by

DICTIONARIVM
ANNNAMITICVM
LVSITANVM, ET LATINVM OPE
SACRÆ
CONGREGATIONIS
DE
PROPAGANDA FIDE
IN LVCEM EDITVM AB
ALEXANDRO DE RHODES
E Societate IESV, eiusdemque Sacræ Congregationis Missionario Apostolico.

ROMÆ, Typis, & sumptibus eiusdem Sacr. Congreg. 1651.
SVPERIORVM PERMISSV.

Alexandre de Rhodes, *Dictionarium Annamiticum Lusitanum et Latinum*.
Rome: Typis Sacr. Congreg, 1651. 70.b.16.

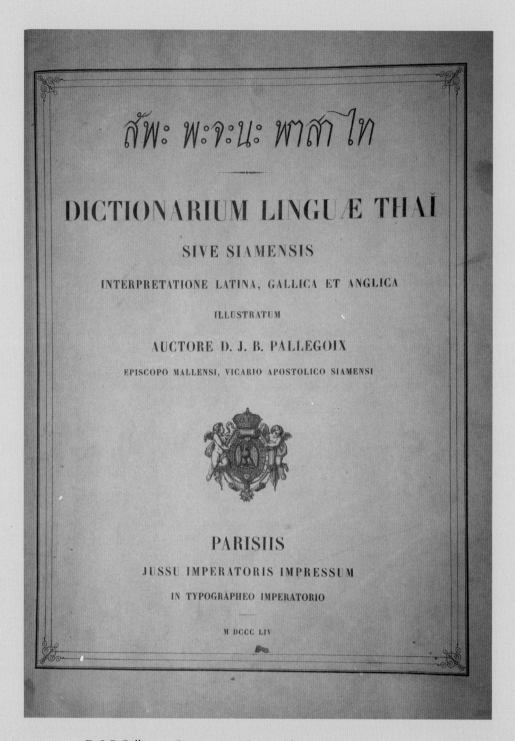

D. J. B. Pallegoix, *Dictionarium Lingue Thai Sive Siamensis*.
Paris: Jussu Imperetoris Impressum, 1854. 825.l.13.

D. J. B. Pallegoix, a French missionary to Siam during the mid-1850s. Entries appear in Thai, Latin, French and English and were arranged according to Roman alphabetical order.

In 1828, *A Grammar of the Thai or Siamese Language*, written by Captain James Low, was published in Calcutta. Low wrote the book while he was serving with the East India Company in Penang. This comprehensive analysis of the Thai language can be regarded as one of the earliest textbooks on Thai grammar in a Western language. The text also contains Thai script and a long Thai–English vocabulary. Low's introduction to the book reads:

> The proximity of the Siamese empire to the British settlements in the Straits of Malacca, and to the lately acquired territory of Tennasserim; the increasing number of Siamese living under British protection in these settlements; and the new political relations which exist betwixt the British and the Siamese courts; have rendered it desirable that facilities should be afforded for the study of the Siamese or Thai language, to those to whom, either from their public or professional situation, a knowledge of it may be advantageous … But it is also manifest, that without the knowledge alluded to, our intercourse with the Siamese must be limited and unsatisfactory, while we cannot expect to gain an accurate acquaintance with their real history and character as a people, or with their ideas, their literature, and their polity.

As more Westerners travelled to South East Asia in the nineteenth century, dictionaries played a vital part in facilitating dialogue with locals. Some travel journals from this period introduced lists of essential words in local languages. For example, Frederick Arthur Neale, who wrote an account of his visit to Siam in 1840, compiled a list of 100 Thai words and 18 Thai numbers in his *Narrative of a Residence at the Capital of the Kingdom of Siam*. When Henri Mouhot's travel diaries of Siam, Laos and Cambodia were published in London in 1864, there was a substantial Cambodian vocabulary and list of phrases in the appendix to his book. These linguistic activities by foreign travellers illustrate Western attempts to understand South East Asian cultures and languages, even though they were primarily to serve their own political and economic interests.

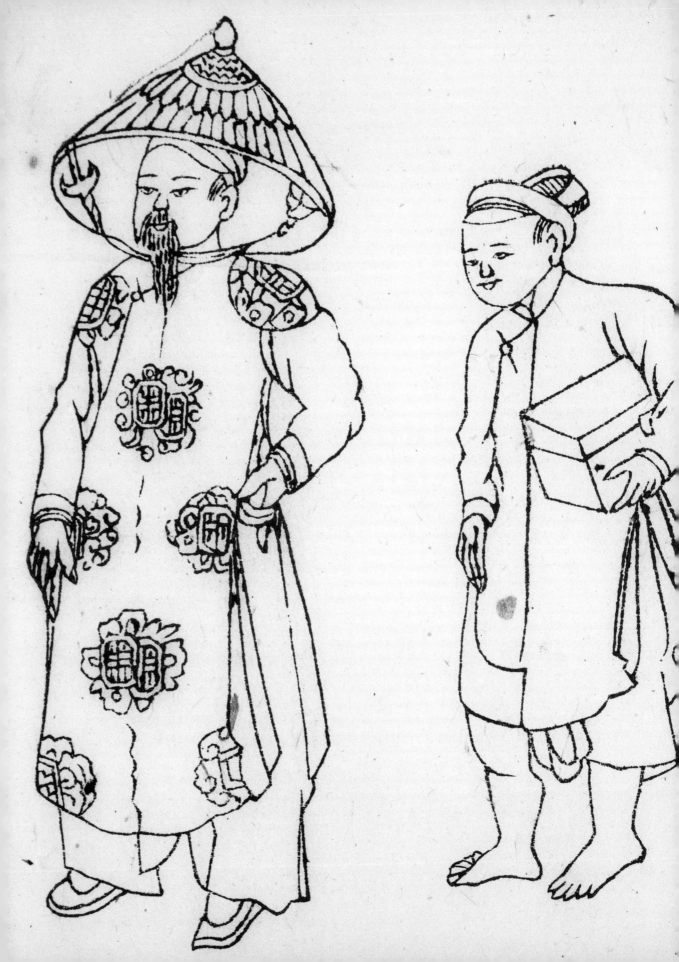

Classes and costume in traditional Vietnamese society

In traditional Vietnamese society people were divided into four classes, similar to those found in Chinese and other East Asian Confucian societies. The *tứ dân*, or four social hierarchical classes, were scholars (*sĩ*), farmers (*nông*), craftsmen (*công*) and merchants (*thương*).

At the top of the social hierarchy were the scholars or intellectuals, who led relatively comfortable lives in respected occupations such as doctors, mandarins and teachers. Commoners who were not born into this class but wanted to climb the social ladder to enter it were able to do so by studying very hard and sitting civil service examinations, supported financially by their own families. If they were successful, they brought great honour upon themselves and their families, and even their villages, and they might be welcomed back home with parties paid for by their neighbours. The royal court would award them special costumes that distinguished them from common folk, and they could even be appointed as local mandarins.

Vietnamese mandarins, both civil and military, were divided into nine grades and each grade was further subdivided into senior and junior levels. High-ranking mandarins were distinguished by their official robes in purple or red, colours reserved for their class, while lower-ranking officials wore blue robes. Commoners could only wear black, brown or white dyed costumes, as Harry A. Franck, an American travel writer, observed in Tonkin in 1923:

> The Tonkinese were dressed in a cinnamon or tobacco-juice colour that suddenly became as universal as black had been further south ... the country women, then their men, and finally all the hand-labouring class, took to wearing long cotton cloaks of this reddish brown hue.

Below the class of scholars was the largest social grouping in Vietnamese society: farmers, primarily rice farmers, who could be

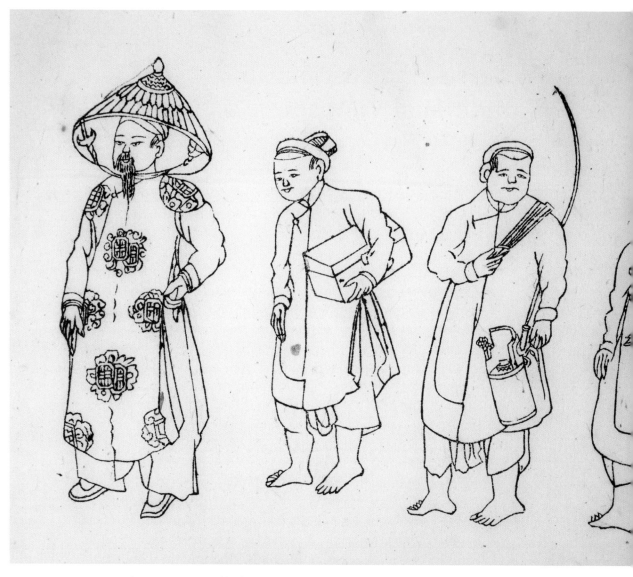

A mandarin accompanied by his servants; only the mandarin wears shoes.
Published by Henri Oger. Or. TC 4, f. 4.

further subdivided into three different groups according to land ownership: *trung nông*, *bần nông* and *cố nông*. *Trung nông* were farmers who owned land and farming tools. This was the most well-off group economically and socially, as they could produce enough

rice or other agricultural products to support themselves, and therefore did not have to labour for the state in lieu of taxation. *Bần nông* were farmers who owned a small amount of land, albeit not large enough to yield sufficient rice to support their families. They therefore had to work on land belonging to landlords, and also had to rent their farming tools. *Cố nông* or tenants were farmers who owned no land or farming tools at all and had to till the land for landlords to earn their living. They were the poorest people in society and were frequently subject to exploitation.

The third class was craftsmen, whose numbers were relatively small compared to farmers. Some were actually farmers who had developed skills in crafts such as carpentry, weaving or blacksmithing. At the village level their scale of production was very small and did not have significant economic impact, but in larger towns they formed their own guilds to protect their interests and to support each other. Those who were highly skilled could be recruited to work for the court, but the court did not support them to develop their production on an industrial scale.

At the bottom of the social hierarchy were merchants. From a modern perspective it may come as a surprise to find that in a traditional self-sufficient economy merchants actually played a very insignificant role, since farmers were able to produce most of their daily necessities and could barter goods with each other, rather than relying on tradesmen. Traditional Confucian society also disapproved of the mercantile practice of 'buying cheap, selling dear'.

Towards the end of the nineteenth century, Vietnamese hierarchical society was still very much intact. Even though French colonial rule brought about some social and economic changes, these were not powerful enough to uproot entirely the traditional system of four social classes. Newly emerging social groups, such as the French-educated literati or colonial employees, still fitted into the scholar class (*sĩ*) despite the different ideological basis.

The number of poor farmers and landless peasants increased, and their plight may even have been exacerbated through colonial land ownership and tax policies.

Traditionally, Vietnamese women wore both skirts and trousers. In the seventeenth century Emperor Lê Hyuền Tông issued a decree forbidding women to wear trousers, but this decision was reversed during the reign of Emperor Minh Mang (r. 1820–41), who instead forbade the wearing of skirts. In the 1820s, George Finlayson wrote of the Vietnamese:

> Though living not only in a mild, but warm climate, the partiality for dress is universal. There is no one, however mean, but is clothed at least from head to the knee, and if their dress is not always of the smartest, it is owing more to their poverty than to their want of taste ... the principal and most expensive article in their dress is the turban ... A loose jacket, somewhat resembling a large shirt, but with wide sleeves, reaching nearly to the knee, and buttoning on the right side, constitutes the principal covering of the body. Two of these, the under one of white silk, are generally worn, and they increase the number according to their circumstances and the state of the weather. Women wear a dress but little different from this, though lighter, and both wear a pair of wide pantaloons, of various colours. The dress of the poorer class is made of coarse cotton, but this not very common, coarse silks being more in vogue. Those of China or Tonquin are worn by the more opulent classes. Shoes are also worn only by the wealthy, and of Chinese manufacture, clogs, in fact, rather than shoes.

Almost a century after Finlayson's account, almost no major changes in the costumes of Vietnamese commoners could be observed. Henri Oger's pictorial records of daily life in and around Hanoi at the turn of the twentieth century (Or. TC 4) illustrate the slow rate of change in social class in this French colony. One might argue that some changes in fashion can be noticed reflecting Western influence, but these mainly affect the elite and wealthy

A peasant farmer in his raincoat made of grass. Or. TC 4, f. 419.

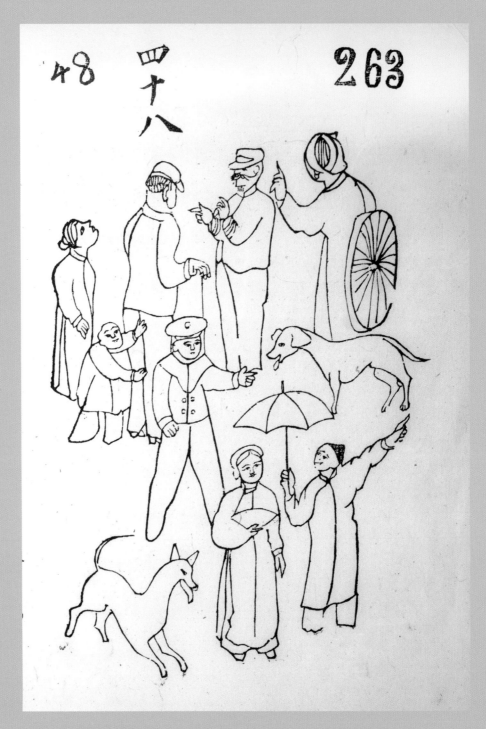

Westerners mingling with locals during the colonial era. Or. TC 4, f. 263.

classes. As for the poor, Oger's drawings suggest that they barely benefited from the social and economic changes brought about by the new rulers.

Harry A. Franck reports on the clothing of the period:

> Among the coolie class these overcoats of both sexes were of thin cotton. The well-to-do men in towns and in autobuses wore jet-black ones, thin as gauze ... with flowered designs of the same hue woven in them ... and fastened together down the side with little gold buttons ... A black cloth carelessly wound about the head distinguished most coolies, but all men above that class wore the most unique item of the Annamese costume, a black band-turban permanently arranged in many little folds ... At least along this main route of the French railway and autobus highway both men and women of the well-to-do class wore gold and other valuable ornaments openly. Long necklaces of grains of gold of the size of peas are the favourite adornment.

茄行笠

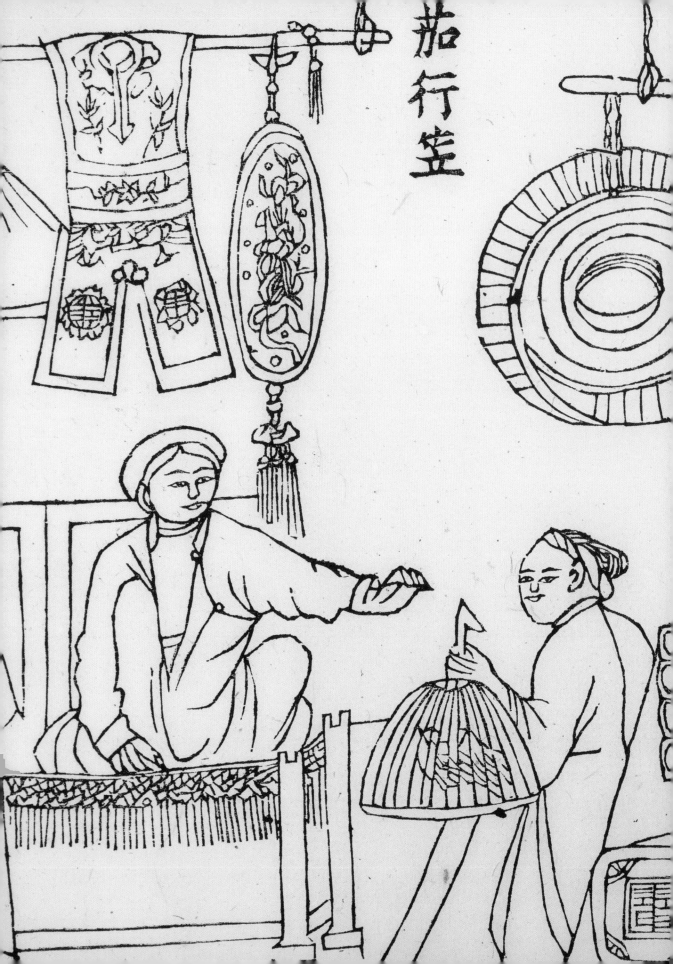

Vietnamese traditional markets

One striking feature of South East Asia is its traditional markets. They can be easily set up in any available space in communities, with vendors laying out their goods on makeshift stalls or on street pavements. Despite global and international retail chains mushrooming in many parts of the region, traditional markets are still thriving, and in many areas are making a comeback.

In Vietnam, traditional markets have often played a vital part in daily life, especially in the past when people still lived under a self-sufficient and rural economy. Markets provided a place where they could trade their daily necessities, while socialising and exchanging local news. Their importance is best expressed by the Vietnamese proverb, 'A market has its regulations; a village has its customs.' Vietnamese traditional markets come in different forms and sizes, from a tiny and basic hamlet market, to a more substantial village market which takes place where roads meet, or a town market, which also has proper shop houses (buildings that combine a shop with simple living accommodation for the trader). Markets could be held on any day of the week. Each area set its own cycle of market days which best served the local community.

Written records of the thirteenth century include some vivid descriptions of the markets of the period. In 1293 Trân Phu, a Chinese envoy of the Yuan dynasty (1279–1368) who travelled through Vietnam during the Trần dynasty (1226–1400), made a note in his records (*An Nam tức sự*) that 'Vietnamese markets took place every two days. Hundreds of goods were laid out. A building of three rooms width with four bamboo benches was erected at every five (Chinese) miles as a place for a market.'

According to the historian Trịnh Khắc Mạnh, traditional Vietnamese markets before the modern period can be divided into two types, those managed by the local administration and those managed by a local temple. Profits from market management would thus go back either to local communities or to the temple.

In the past, markets were not only a place for business but also served as a community's centre where locals were able to socialise. Both traders and customers also had a chance to meet up and exchange or gather news about their neighbours and communities. A market was a place where other daily activities took place, as a line from a folk song about a girl looking for a man of her dreams demonstrates: 'I'm like a length of rose silk / Waiting in the market for the right buyer.'

Markets in small villages or communities required no permanent fixtures. They could be easily set up with makeshift stalls, benches or even just a piece of cloth laid out on the bare ground. Markets in towns were generally bigger and would also have permanent shop houses. In the eighteenth and nineteenth centuries in prominent towns such as Saigon, Hanoi or Huế there were markets that specialised in one particular trade, such as clothes, paper, tin and copper household utensils, and leather. Street names in the old quarter of Hanoi clearly reflect the specific commercial history of parts of the city, as each name gives you a clue as to what you could expect to buy from the area. For example, *Phố Hàng Đào* was a place where you could buy silk or fabric, *Phố Hàng Bạc* specialised in silver products whereas *Hàng Chiếu* would have plenty of sleeping mats for you to choose from. Some of these traditions still carry on to the present day.

Records of Western travellers to the region in the nineteenth century also give good accounts of what traditional markets were like. George Finlayson, a surgeon and naturalist attached to the Crawfurd Mission to Siam and Vietnam in 1821–2, gave an account of the principal market in Huế, which he visited on 3rd October 1822, as follows:

> It consists of a spacious street about a mile in length, with shops on either side of the whole of its length. Many of the shops are mere paltry huts, made of palm leaves; the rest are more substantial houses, constructed chiefly of wood, and have tile or thatched roofs. Here also, the poverty of the shops was particularly striking. A very large proportion contained nothing but shreds of gilt and coloured paper used in religious ceremonies and at funerals. Chinese porcelain, of a coarse description; fans, lacquered boxes,

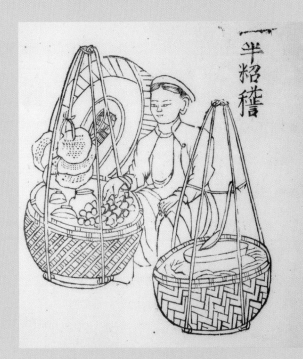

Food vendor.
Or. TC 4, f. 75.

Paper shop.
Or. TC 4, f. 131.

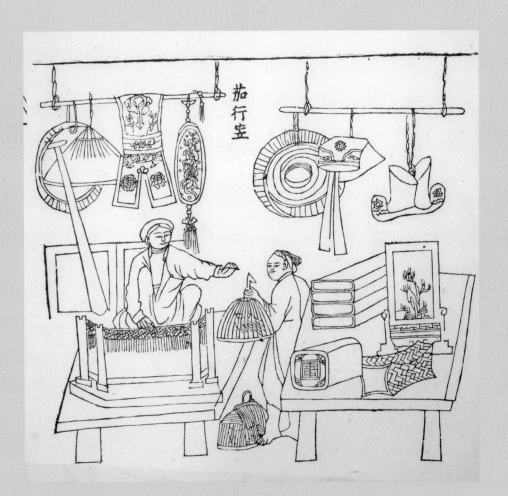

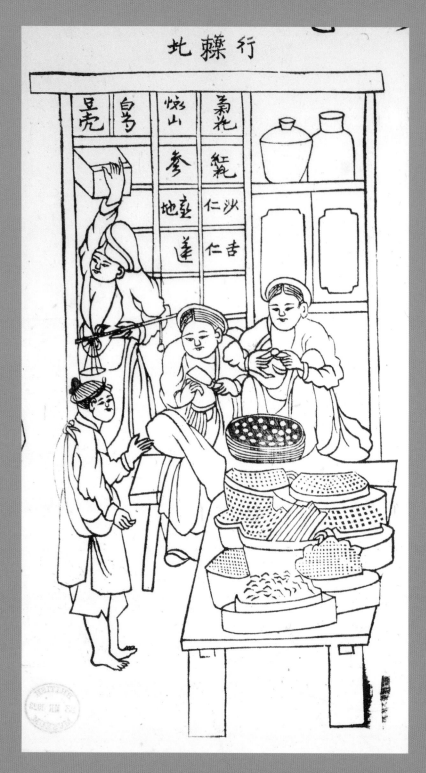

Pharmacy. Or. TC 4, f. 90.

Chinese fans, silks, and crapes, the two latter in small quantity; medicines without number, coarse clothes made up, large hats made of palm-leaf, and a sort of jacket of the same material; rice, pulse, and fruit; sago ... were the common articles exposed for sale. There were but few, and those very coarse articles of manufactured iron, as nails, hatches, and chisels, which bore a high price.

The British Library is fortunate to hold some items that depict Vietnamese markets at the beginning of the twentieth century. The three-volume set of *Introduction générale a l'étude de la technique du peuple annamite* by Henri Oger, published in Paris in 1909 (Or. TC 4), has detailed and informative drawings of daily activities of the Vietnamese in and around Hanoi in the first decade of the twentieth century. In addition to this finely illustrated item, the *Ký Họa Về Đông Dương: Nam Kỳ* (*Monographie Dessinée de L'Indochine: Cochinchine*), (OIJ.915.97), republished in 2015, depicts the daily life of the Vietnamese in the Gia Định/Saigon area in the 1920s and 1930s. The book was first published in Paris in 1930. It is a collection of beautiful drawings from the Gia Định School of Drawings (*Trường vẽ Gia Định* or Ecole de Dessin, founded in 1913, the predecessor of the present University of Fine Arts, Ho Chi Minh City). Both items are wonderful historical records of the lives of Vietnamese commoners at the turn of the twentieth century.

Vietnam War art

The Vietnam War had a catastrophic effect on the country, with a devastating impact on the land and on human settlements and the loss of hundreds of thousands of lives. Estimates of casualties from the war vary widely. In 1995 the Vietnamese government released figures estimating that around 1.1 million of their soldiers and the Việt Công fighters lost their lives and that there were about 2 million civilian deaths. As for the Americans, it has been estimated that more than 60,000 of their servicemen were killed. During the 1960s and 1970s, artists from both sides of the conflict, Vietnamese and American, created paintings to capture the human side of the war.

In June 1966, the Army Vietnam Combat Artists programme was established as part of the United States Army Art programme. From August 1966 through to 1970, the US Army sent teams of artists into Vietnam to record their experiences.

Weaving by Dương Đình Khoa in *Báo Ảnh Việt Nam*, no. 139 (1969), p. 19. SU216(2).

In Vietnam, art was also utilised as a propaganda tool to enlist mass support for the war. In the North the Hanoi College of Fine Arts, which was founded by the French in 1925 during the period of colonial rule, played a vital role in training artists during the Vietnam War, while in the South, from 1961 unofficial art classes began in the Resistance or 'liberated' areas controlled by the National Liberation Front (NLF) or the Việt Cộng in the Mekong Delta. From June 1962 patriotic artists from the North volunteered to go to the South to train fellow artists in the liberated zones. From 1964, official art classes started at NLF headquarters.

Mother Heads to the Alert Unit. by Nguyễn Phan Chánh in *Báo Ảnh Việt Nam*, no. 167 (1972), p. 13. SU216(2).

Grandmother by Phạm Viết Song in *Báo Ảnh Việt Nam*, no. 152 (1970), p. 15. SU216(2).

After the Battle. Watercolour by Việt Sơn in *Báo Ảnh Việt Nam*, no. 161 (1971), p. 9. SU216(2).

Despite hardships and difficulties, artists from both the North and the South risked their lives to capture many different aspects and events of the War in various media including paintings, drawings and sketches. Nguyễn Toan Thi, a guerrilla artist in the South, who after the War became the Director of Ho Chi Minh City Fine Arts Museum, recounts his experiences as follows:

Art classes were held outside in the forest until our schools were bombed: classes were then held underground. Art teachers and students shared the same trenches. We fought and sketched together, to record spontaneous and realistic images of the

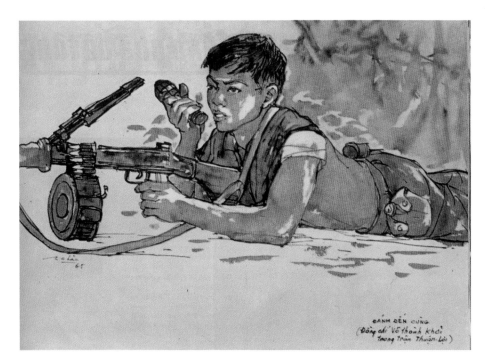

Fight Till the End by Cố Tấn Long Châu in *Báo Ảnh Việt Nam*, no. 115 (1967), p. 9. SU216(2).

battlefield and our life in the forest. Our headquarters were not like a mini-Pentagon. The administration, soldiers and artists lived in nylon and canvas tents under the forest trees ... We moved camp every two or three days ... As a guerrilla artist, I was fully engaged in the fighting. Unlike artists who were civilians.

(Quoted in Sherry Buchanan, *Mekong Diaries 1964–1975*.)

In 1966 the Fine Arts Museum opened in Hanoi and occasionally displayed works from the Vietnam War artists. In addition to these exhibitions, the Hanoi regime also published artworks in their various official publications. Although the British Library does not hold original examples of this artwork, it has a number of official publications in its Vietnamese collections, which published artworks from the Vietnam War during the 1960s and 1970s. All the pictures shown here were reproduced in *Báo Ảnh Việt Nam*, which started publication before the War and still operates today.

Women and the Vietnam War

A large number of women were directly engaged in the Vietnam War. On the American side, there is no precise figure but it is estimated that between 5,000 and 11,000 women worked as nurses, whilst others had mostly clerical roles, or were involved in war journalism. Vietnamese women took a much more active role than their American counterparts and a good number were members of armed units and engaged in direct action against their enemy.

Traditionally, Vietnamese women were supposed to follow Confucian teachings. They were expected to observe chastity, to practise three submissions and obey three masters, namely their father, their husband and their eldest son. In work, they were expected to master cookery, sewing and embroidery but would not normally engage in reading and writing. In their physical appearance they were expected to dress in way that made them attractive to their husbands but not enticing to others – not an easy balance to strike.

These traditional dogmas for women were challenged from the beginning of the twentieth century. During this period women were recognised as part of the national polity, at least in theory, and concrete proposals were made for expanding their educational opportunities. From the 1920s women's organisations were formed, and debates on women's roles – both traditional and modern aspects – were conducted in the media and in literature. While the Vietnamese struggle against French colonialism increased in the 1930s, Nhất Linh, one of the leading progressives and members of the intelligentsia, gave a new definition of filial piety. It no longer needed to signify blind obedience to one's elders or the selfless pursuit of family interests; it was more reasoned and noble and could serve as the wellspring of patriotism. On the other hand, non-Marxist attitudes toward women moved even further towards the right, and they glorified the 'heaven-determined function' of women within the family.

The Girl and the Lotus Flower, 1943, oil painting by Tô Ngọc Vân (1906–1954). The artist, who trained during the French colonial period, was the director of the School of Fine Arts in Hanoi under the Vietnamese Communist Party regime after 1945. He subsequently trained artists during the war against the French before he was killed by bombing in 1954. Reproduced in *Việt Nam*, 4.43 (1961), p. 12. SU216.

Mother and Son, 1957, silk painting by Nguyễn Phan Chanh. The artist abandoned silk painting during the Resistance War against the French (1946–54) and produced posters to support war efforts. He returned to his traditional painting after the Resistance War. Reproduced in *Việt Nam*, 7.46 (1961), p. 12. SU216.

Caught between these controversies, the efforts of the Vietnamese Communist Party to reach out to women and recruit them into its auxiliary groups continued to be hampered by women's dual burden at home and in society. Nevertheless, they were successful in recruiting women to join the Party. As the political scientist Mary Ann Tétreault points out:

> Vietnamese revolutionaries did more than use gender as a code through which to discuss the penetration of their society by the French. They appealed directly to women to participate in the struggle to liberate their country, promising them in return

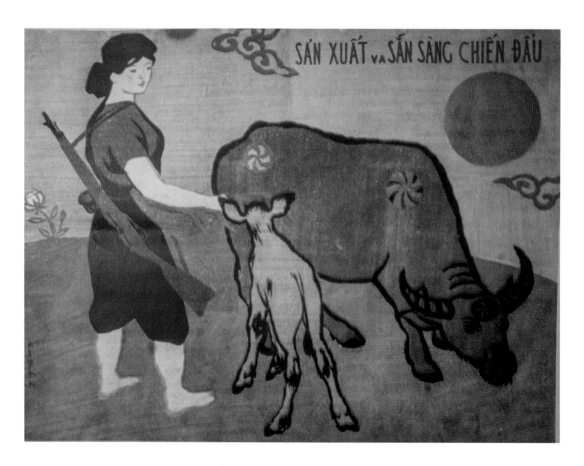

Produce and Prepare to Fight the War (*Sản xuất và sẵn sàng chiến đấu*) by Huy Oánh in *Việt Nam*, 101.2 (1966), p. 13. SU216(2).

equal political, social, and economic rights and status under a
new regime. These appeals attracted women who felt oppressed
by the old regime ... Vietnamese women seeking equality found
revolutionaries to be the only group in their society willing to
commit themselves to achieving it. It is not surprising that so
many responded by joining the movement.

During the Vietnam War years, Vietnamese women had to
perform both traditional and new wartime roles as required by
the Party. Ho Chi Minh himself encouraged Vietnamese women to
extend their roles during wartime and praised women in the South
who fought against the US-supported regime. Meanwhile, he urged
women in the North to take part in fighting against the US in order
to save the country and to build socialism.

When the war was intensified after direct American involvement
in the 1960s, Hanoi adopted the 'three readies' policy (*ba sẵn sàng*)
and asked the entire population to be ready to fight, to join the army
and to go anywhere required by the Fatherland. Women actively
took part in this policy and the 'three undertakings movement' (*ba
đảm đang*). According to official figures, by the end of May 1965
more than 1.7 million women had signed up for the title of 'Three
Undertakings Woman'. They took up a wide range of tasks, from
domestic roles to working on farms and in factories, in order to
allow men to go to fight at the front line. They also took part in
fighting as armed guerrillas or in the self-defence militia. Ho Chi
Minh personally sent commendations to mothers who lost their
sons in the war or made awards to women who fought the enemies.

By the 1960s, Vietnamese women were shouldering a dual
burden, at home and for the fatherland. They were commended by
Ho Chi Minh on 20 October 1966 on the occasion of the anniversary
of Women's Association: 'Vietnamese women bravely fight against
the US ... from past to present, from the South to the North, from
young to old, Vietnamese women are genuine heroes'.

Nguyễn Thị Định (1920–1992) arguably epitomised Vietnamese
women during the Vietnam War. She was born into a peasant family
in southern Vietnam. She joined the Viet Minh and was involved in the

Protect the Fatherland's Sky (*Bảo vệ bầu trời tổ quốc*) by Quang Phòng and
Mai Văn Hiến in *Việt Nam*, 114.3 (1967), p. 9. SU216(2).

revolutionary movement and the fight against French colonialism in the 1940s. She was a founder member of the National Liberation Front, the first female major general to serve in the People's Army of Vietnam and one of the Deputy Chairmen of the Council of State from 1987 until her death.

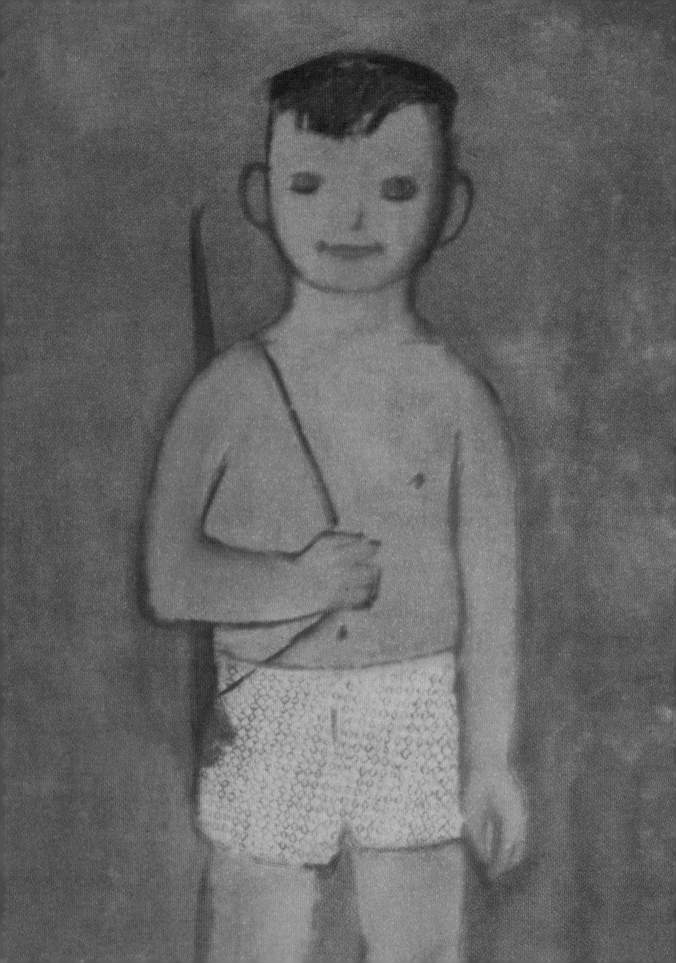

Children in
the Vietnam War

Ho Chi Minh: 'The Working Youth Union members and our young people are in general good; they are ready to come forward, fearless of difficulties and eager for progress. The Party must foster their revolutionary virtues and train them to be our successors.'

(*Việt Nam,* commemorative issue on the death of Ho Chi Minh, October 1969, p. 11.)

The Vietnam War affected people from all walks of life in Vietnam, and children were not spared from the cruelty of this war. The physical suffering from heavy battles and bombardment of highly toxic chemical weapons are still felt today. During the war years life for children was very hard, in both North and South Vietnam. Houses and schools were bombed and destroyed. Many children became homeless and their schools had to be moved around or lessons had to take place after dark to avoid being targeted by heavy bombings. For example, one school in a liberated area in the South had to move site three times in four months due to the American air raids. Wherever they stopped, teachers and pupils built bamboo and palm leaf cottages in the midst of forests as their school.

In the face of these hardships, the fighting spirit of the children was heavily fortified by the Vietnamese Communist Party and the National Liberation Front, and these institutions made children very aware of foreign enemies and their duty to serve their country. The attempts of the Vietnamese Communist Party and the National Liberation Front to inspire young minds to fight the enemy are illustrated by the glorification of Nguyễn Văn Trỗi, a young electrician and a Viet Minh member in the South. Trỗi was sentenced to death and executed by a firing squad in Saigon in front of the press on 15 October 1964 for the attempted assassination of Robert McNamara, the US Secretary of Defence, who was visiting

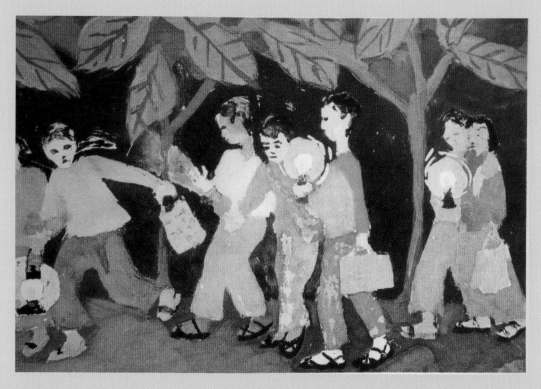

'Going to school at night' (*Đi học đêm*) by Phi Tiến Sơn, twelve years old. *Việt Nam*, no. 155 (1971), p. 14. SU 216(2).

Execution of Nguyễn Văn Trỗi. *Việt Nam*, no. 149 (1970), p. 31. SU216(2).

South Vietnam in May 1963. When the shots were fired at Trỗi, he shouted 'Down with the US imperialists, long live Vietnam, long live Hồ Chí Minh'.

Hanoi treated Trỗi as a martyr and renamed many schools, prizes and other revolutionary activities after him. In the liberated zones in South Vietnam, revolutionary schools named after him were set up to teach children about 'learning for victory over the Yanks'.

According to one Hanoi publication:

> A system of revolutionary education has taken shape and is fast growing. With this the innocent and unstained minds of children can absorb the cream of the sound and rich national culture very early, and the children will work their way to become good sons and daughters, excellent pupils and young activists. In the 'small deeds, great significance' movement, apart from learning, they enthusiastically join their efforts with those of their parents and brothers in fighting the enemy and defending their villages and hamlets.
>
> *Việt Nam*, no. 141.6 (1969), p. 29.

Against this background, children as young as thirteen and fourteen were involved in the armed struggle, learning guerrilla warfare tactics and killing both American and South Vietnamese soldiers. Some were trained to be informants. Many of them were decorated with awards and 'glorious titles' such as 'Iron Fort Children' or 'Valiant Destroyer of the Yanks'. Others were involved in war-related activities such as making hats for soldiers, constructing strategic roads to reach the South, barricading or fortifying their schools and even just giving moral support to members of their families before they left home to fight in the front line. In the North the Party arranged activities to keep young minds aware of the ongoing war and its horrible repercussions on their life. For example, painting competitions for young people on war themes were organised by some newspapers and cinemas. In the South a campaign to enlist support from young people was launched by the Provisional Revolutionary Government. They were encouraged to engage in 'five volunteer movements', i.e. to volunteer to destroy

'Tiny guerrilla' (*Du kích tý hon*) by Lưư Công Nhân. *Việt Nam*, no. 106.7 (1966), p. 9. SU216.

as much of the enemy's manpower as possible, to join the army, to wage political struggle, to serve on the frontline and to boost agricultural production.

The War also led to the rapid expansion of the sex industry, especially between American servicemen and local women. Around 300,000 women worked as prostitutes during the Vietnam War period. In the South, a new generation of children was brought into the world as a consequence of wartime relationships between American soldiers and local women. It has been estimated that there were about 50,000 mixed-race children; they faced many hardships in life during but especially after the war, as they were regarded as outcasts by the Vietnamese. They were referred to as *bụi đời* or the 'dust of life'. When, in 1987, the US government eventually set up a

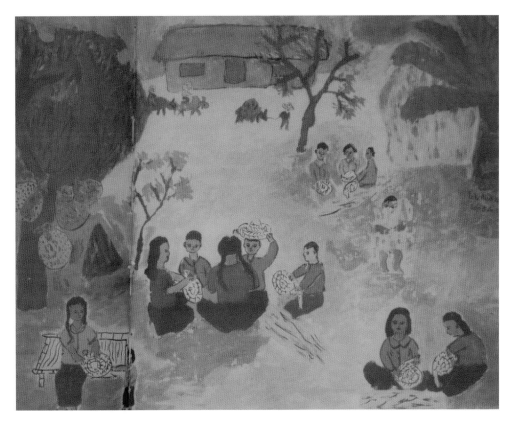

'We weave straw hats to fight the US' (*Chúng em tết mũ rom chống Mỹ*) by Bùi Quang Trường, thirteen years old. *Việt Nam*, no. 141 (1969), pp. 18–19. SU216(2).

programme to allow these Amerasians to settle in the USA, some of them were able to leave Vietnam and to be reunited with their paternal families in the USA.

NOTE: As the British Library collection of Vietnamese serials comes mainly from North Vietnam, the nature of content for this section only reflects information from the North, especially as found in the periodical *Việt Nam*, published in Hanoi.

War cartoons and propaganda from North Vietnam

During the early stages of the Vietnam War in the 1960s, the Democratic Republic of Vietnam (North Vietnam) had two urgent tasks. The first was to produce enough food to supply their armed forces as well as the population as a whole, in order to ease the early days of the transformation of North Vietnam into a communist state. The second task was to prepare the country for war, especially after the United States of America became involved. To achieve these two goals, the regime in Hanoi tried various means of communicating with the people in order to maximise their contribution to the successes of the country. It was stressed that it was not only men who could participate in this noble task, but all sectors of society, including women, youths and the various ethnic groups.

Under the strict socialist regime, different forms of regulated and controlled media, including newspapers and magazines, were used to help the government to meet its objective. Both content and illustrations in the media always emphasised the successes of the war and of food production, to boost the morale of the public during a difficult period. At the same time, they never failed to ridicule their enemies, whether the American or South Vietnamese administrations.

The British Library holds a small but rich collection of provincial and local newspapers from North Vietnam, published by local branches of the Vietnamese Workers' Party from 1964 to 1965. Some of the cartoons and drawings from these newspapers are shown in the following pages.

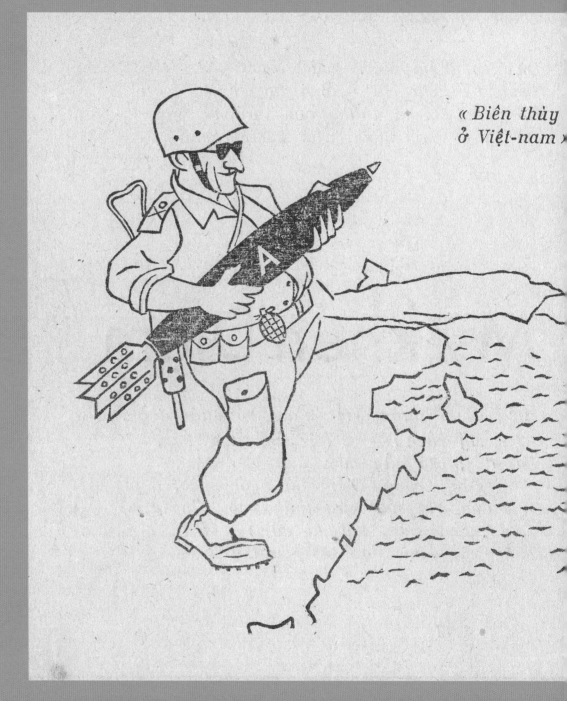

'US territory stretches to the 17th parallel of Vietnam,' President Ngô Đinh Diệm of the Republic of Vietnam announces at New York on 13 May 1957. *Văn*, no. 5 (7 June 1957), front page. SEA.1986.c.60.

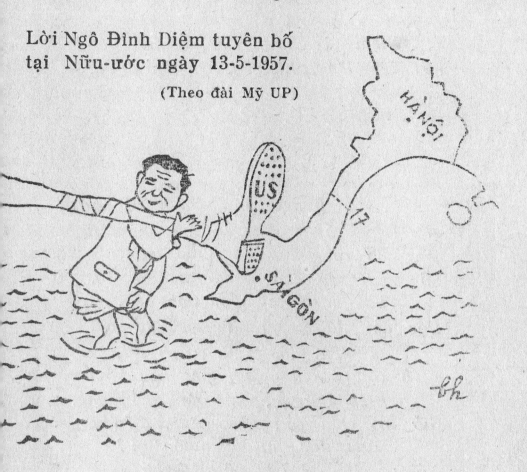

Hoa-kỳ kéo dài đến tận vĩ tuyến 17

Lời Ngô Đình Diệm tuyên bố
tại Nữu-ước ngày 13-5-1957.

(Theo đài Mỹ UP)

TRANH CỦA MAI VĂN HIẾN

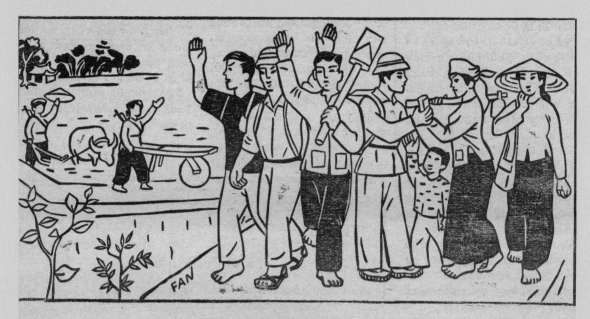

Anh đi bộ đội diệt thù
Anh đi xây dựng biên khu đẹp giàu
Bây giờ ta bắt tay nhau
Hẹn ngày chiến thắng ca câu khải hoàn
Ở nhà phụ nữ lo toan....

Tranh : HOÀNG ANH PHAN

'You join the army to kill the enemies / You go to the frontier zone / We have to say good-bye now, wait for the victory day / At home (we) women will manage to take care of other business.'
Hải Dương Mới, no. 314 (12 May 1965), p. 4. SU224/18.

'Weeding and Applying fertiliser to the soil to get a good yield of winter crops.'
Hà Giang, no. 351 (10 August 1965), front page. SU224/17.

Tránh mưa, cướp nắng ban ngày
Để ta đập, trục, phơi ngay sạch, giả
Làm nghĩa vụ với nước nhà
« Chống Mỹ, cứu nước » — có ta góp phần

Tranh : HOÀNG ANH PHAN

'Protected from the rain and kept out of the heat during the day / To allow us to thresh and dry out crops / To fulfil our responsibility to the country / "Fighting America" to save the country – we have contributed.'
Hải Dương Mới, no. 318 (26 May 1965), p. 4. SU224/18.

'Push up production, prepare for fighting the war.'
Hải Dương Mới (21 July 1965), front page. SU224/18.

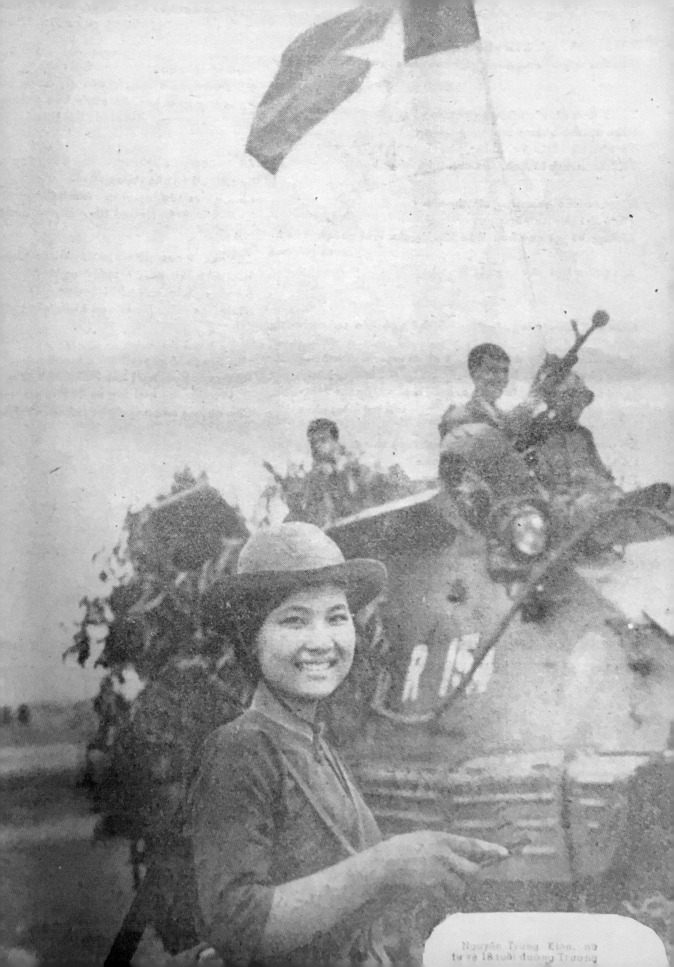

Nguyễn Trung Kiên, nữ
tự vệ 18 tuổi đường Trường

Anniversary of the
end of the Vietnam War

For a large number of the Vietnamese living either in Vietnam or abroad, 30 April of every year marks the end of the Vietnam War. On 30 April 1975, the Vietnam War, or the Resistance War against America as it is known by the Vietnamese, came to an end when North Vietnamese troops entered Saigon just before midday and President Dương Văn Minh of South Vietnam surrendered at the Presidential Palace in Saigon. One of the most iconic images which marks the end of the war is that of a North Vietnamese tank storming into the front gate of the Presidential Palace. Following the Paris Peace Accord of 27 January 1973, Hanoi had started a final push under the Ho Chi Minh Campaign with the aim of seizing Saigon by 1975. The capture of Saigon brought jubilation to many Vietnamese, who were exhausted from the long war.

The Vietnamese press took the opportunity to capture the public mood by depicting their cheerful and celebratory emotions in a variety of formats. Articles, poetry, songs, paintings and drawings about the historic victory over the Americans and the unification of North and South Vietnam were widely published. The long and painful history of the war is probably best summed up by just a few frames of drawings from *Tiền Phong* (*Vanguard*), a weekly newspaper from Hanoi, in its 6 May 1975 issue. These illustrate the history of American involvement in the Vietnam conflict, from when the US refused to sign or acknowledge the Geneva Accord in 1954 and decided to support Ngô Đình Diệm as the leader of the Republic of Vietnam (South Vietnam). This was followed by a military escalation under the Johnson administration in 1965, the Tết Offensive in 1968, the Nixon Doctrine and Vietnamisation in 1972 when President Richard Nixon decided to withdraw the American military from the war, and eventually the victory of Hanoi in 1975.

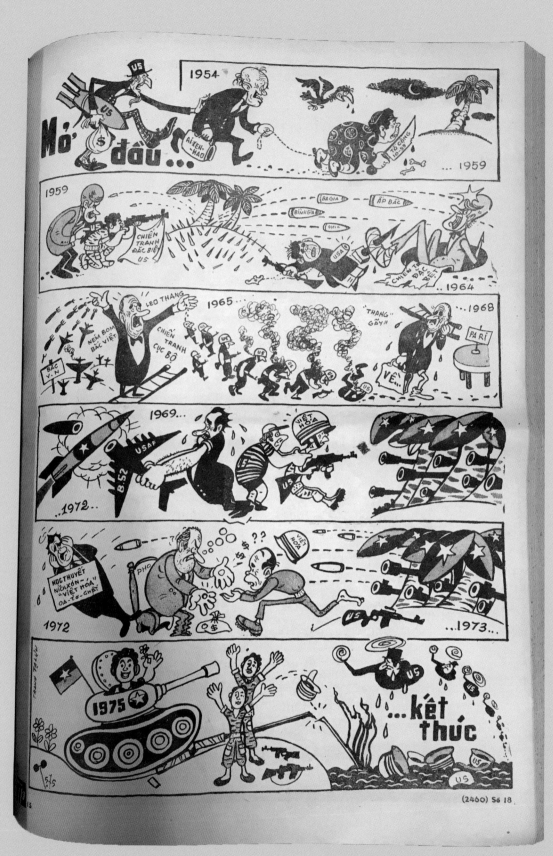

Hanoi's successes in driving out the Americans and their allies from Vietnam and the reunification of the country have been immortalised in repeated images of the events. *Tiền Phong* (no. 18, 6 May 1975, p. 5) published a drawing of the Americans being swept out from the country. The front cover of this issue also depicted an event of the communist forces capturing *Tân Sơn Nhất* airport. Twenty years later, in its issue 437 (May 1995), *Báo Ảnh Việt Nam* celebrated the twentieth anniversary of the end of the war by publishing a photo of Vietnamese children having fun with a tank from the war era.

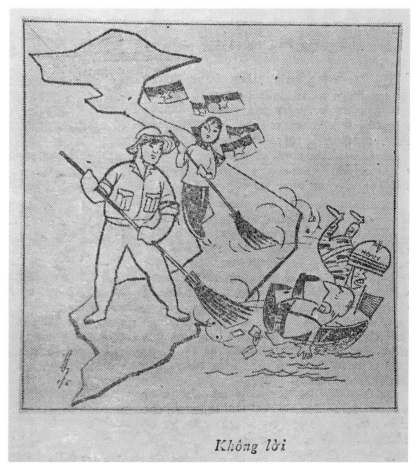

Không lời

Above: The Americans being swept out from the country.
Tiền Phong, no. 18, 6 May 1975, p.5. SU224/2

Opposite: *Tiền Phong*, no. 18, 6 May 1975, p. 15. SU224/2.

However, not every Vietnamese embraced the Hanoi victory of April 1975. The anti-communist Vietnamese who managed to leave the country and settled abroad, especially in the United States, Canada and France, organised resistance movements in attempts to bring down the communist government in Vietnam. One of the most active movements was the National United Front for the Liberation of Vietnam (*Mặt Trận Thống Nhất Giải Phóng Việt Nam*), founded by Vice Admiral Hoàng Cơ Minh on 30 April 1980 in California. Key members of this Front were former military officers or government employees of the Republic of Vietnam (South Vietnam). For a large number of overseas Vietnamese, 30 April brought back bitter memories and they normally had different reasons to commemorate the day, the aim being to fight against the Democratic Republic of Vietnam. The resistance movement against

Above: A collection of Vietnam War cartoons poking fun at American soldiers. ORW1986.a.3485.

Opposite: Capturing *Tân Sơn Nhất* Airport. *Tiền Phong*, no. 18, 6 May 1975, front cover. SU224/2

VÌ CHỦ NGHĨA XÃ HỘI,
VÌ THỐNG NHẤT TỔ QUỐC,
VÌ LÝ TƯỞNG CỘNG SẢN,
THANH NIÊN ANH DŨNG TIẾN LÊN !

NĂM THỨ XXII

SỐ 18
(2460)
RA NGÀY 6.5.1975

Tiền phong

CƠ QUAN TRUNG ƯƠNG CỦA ĐOÀN THANH NIÊN LAO ĐỘNG HỒ CHÍ MINH

MỪNG VIỆT NAM ĐẠI THẮNG!

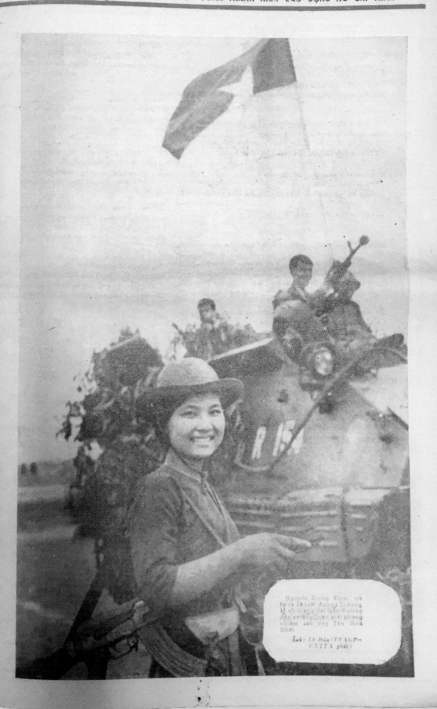

Nguyễn Trung Kiên, nữ tự vệ 16 tuổi đường Trương Minh Giảng (Sài Gòn) hướng dẫn xe tăng Quân giải phóng chiếm sân bay Tân Sơn Nhất.

Ảnh: Lê Dân (TTXGP—VNTTX phát)

LỬA VIỆT

Giá Bán $ 2.00
Tại Toronto $ 1.50

53

THÁNG TƯ TÁM LĂM

TẠP CHÍ ĐẤU TRANH VĂN HỌC NGHỆ THUẬT

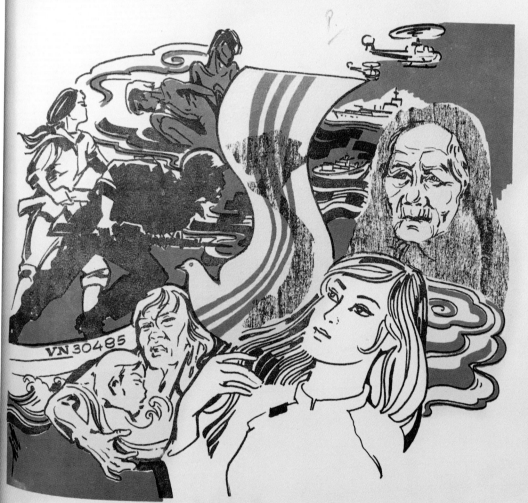

VN 30485

SỐ ĐẶC BIỆT QUỐC KHÁNG TÁM LĂM

TUẦN LỄ VIỆT-NAM TỰ-DO TẠI TORONTO

Lửa Việt: anti-Hanoi publications by overseas Vietnamese in Canada. April, 1985.
16641.e.12.

Hanoi among overseas Vietnamese was most active in the 1980s and 1990s. There were attempts to recruit Vietnamese abroad for military training and send them back to operate in Vietnam. These activities also brought about diplomatic tension between Vietnam and Thailand, since some of these movements used Thai territory as their base of operations.

Overseas Vietnamese publications, especially in the United States and Canada, lent support to the resistance movements. There were articles dedicated to reporting the movements. On the anniversary of the end of the Vietnam War (April or May issues), they published special issues to remind themselves of the bitter experiences of the war years, their nostalgia and determination to fight against the communist regime with a bellicose approach.

However, after more than two decades of unsuccessful action by the resistance movements, together with the economic changes introduced by Hanoi, known as *Đổi Mới* (economic renovation) towards the end of the 1980s, Vietnam appeared eventually to achieve what the country had fought for: unification and peace.

VIETNAMESE TITLES
L-Q

Vietnamese collection milestone: retroconversion of the card catalogue

Curators at the British Library are aware that the extensive and rich source materials in our collections are of no use unless our users can access them, or at least become aware of their existence. In the Asian and African collections, in recent years we have been encouraged to clear backlogs and to make source material in the collections searchable online.

The Online Computer Library Centre (OCLC), the first online library catalogue, was launched at Ohio University in August 1971. Although this seminal event occurred almost half a century ago, it was a long time before online cataloguing was adopted by institutions worldwide. Even into the 1980s and 1990s, some collections were still being catalogued manually, often due to issues relating to the transliteration of non-Roman scripts and the use of diacritics. The cataloguing of the Vietnamese collection at the British Library fits into this category perfectly, due to problems with inputting the double diacritics needed for Vietnamese. When I took up my post as curator for Vietnamese at the British Library in 2005, most of the printed materials in our collection were still catalogued using old-fashioned catalogue cards, and hardly anything was searchable online. One of my major tasks has been to retroconvert the Vietnamese card catalogue onto the British Library's online catalogue, and that task is now virtually complete.

This mammoth project was conducted in two phases beginning in around 2007. I called up almost every single Vietnamese printed book to physically check that it was the correct one before I created an online record. This process was slow but was more likely to lead to fewer mistakes, such as mismatches between shelfmarks and items, or duplication of records. In October 2014, I was able report

Opposite: Drawers of Vietnamese catalogue cards in the Asian and African Studies Reading Room in the British Library at St Pancras in London.

```
                              16694. a. 176.

CÂU TRẢ LỜI

  Câu trả lời / Hàm Châu ...[et al.]; bìa và minh
  hoa của Cửu Long Giang. -- Hà Nội : Kim Đồng,
  1976.
  73p.
  a1. HÀM CHÂU. a2. CỬU LONG GIANG. s1. Litera-
  ture--Juvenile.

                              Vietnamese.
```

Vietnamese book *Câu Trả Lời*, 16694.a.176 (left), previously only catalogued on card (above), which has now been recatalogued online (below).

Leader	L D R	_ _	^^^^^nam^a22^^^^^^i^4500
Ctl. No.	001	_ _	018555946
Ctl. No. ID.	003	_ _	Uk
Date and Time	005	_ _	20171017133821.0
Fixed Data	008	_ _	171017s1976^^^^vm^a^^^j^^^^^\|0\|0^0\|vie^^
Catal. Source	040	_ _	a Uk
			b eng
			c Uk
			e rda
Authent. Code	042	_ _	a ukblsr
Personal Name	100	0 _	a Hàm Châu,
			e author.
Main Ti.	245	10	a Câu trả lời /
			c Hàm Châu [and others] ; bìa và minh hoạa của Cửu Long Giang.
Publication	264	_ 1	a Hà Nội :
			b Kim đồng,
			c 1976.
Phys. Desc.	300	_ _	a 73 pages :
			b illustrations ;
			c 19 cm
Content type	336	_ _	a text
			2 rdacontent
Media type	337	_ _	a unmediated
			2 rdamedia
Carrier type	338	_ _	a volume
			2 rdacarrier
Subject-Geo.Trm	651	0 _	a Vietnam
			x Juvenile fiction.
Finished	FIN	_ _	a Y
			d 20171017

with some satisfaction that the retroconversion of the Vietnamese printed collection had been completed. However, the satisfaction of this achievement turned out to be rather short-lived as, not long afterwards, in June 2016, during office relocation moves one of my colleagues found four cardboard boxes brimful of Vietnamese catalogue cards. When I randomly checked some cards to see whether they had been retroconverted in the first phase, none of them came up on a search on the British Library's online catalogue Explore, meaning that all these cards also had to be recatalogued online.

Hence my second phase of retroconversion began in August 2016. Judging from the amount of cards in those four boxes, which seemed to number well over 10,000, I could not afford to use the same very thorough method for cataloguing as I had done in the previous phase. I therefore decided to rely on the bibliographic record appearing on each card as the major source for recataloguing, and only if there were serious doubts or queries would I call up the physical item in question to check. This method helped to speed up the cataloguing process. Fortunately, a large proportion of cards turned out to be duplicates and could be discarded; in the end, only just over 2,400 catalogue cards had to be retroconverted. During this second phase of retroconversion, I found that problems certainly arose from my not having physically seen all the items before creating new online records. There were sometimes mismatches between shelfmarks and items, or different items shared the same shelfmarks. These problems had to be resolved, for otherwise they would have caused confusion and frustration for users when calling up items for consultation.

Finally, I can now at last report that all our old Vietnamese catalogue cards, except for just a few problematic ones, have been retroconverted and are searchable online through the British Library's online catalogue. Together with new acquisitions, there are now more than 11,000 titles in the Vietnamese collection. I very much hope that the completion of this project will enable our readers to access more readily source material in Vietnamese in the British Library, either for research or enjoyment, as set in our mission statement 'Living Knowledge'.

Bibliography

Ai Hoa. 'Năm thìn kể chuyện Rông' in *Quê Mẹ*, Số 88–89, 1988, pp. 7–8.

James R. Brandon, *Theatre in Southeast Asia*. Cambridge, MA: Harvard University Press, 1967.

Sherry Buchanan, *Mekong Diaries 1964–1975*. Chicago: University of Chicago Press, 2008.

Joseph Buttinger, *A Dragon Defiant*. Newton Abbot: David and Charles, 1983.

Sud Chonchirdsin, 'Cartoons and Propaganda from North Vietnam during the Early Stage of the Vietnam War', SEALG newsletter, no. 44 (December 2012), pp. 6–21.

Đinh Xuân Lâm, chủ biên. *Đai cương lịch sử Việt Nam*, vol. 2. Hanoi: Nhà xuất bản giaó dục, 1999.

William J. Duiker, *China and Vietnam: The Roots of Conflict*. Berkeley, CA: University of California Press, 1986.

Dương Thoa. *Bác Hồ với phong trào phụ nữ Việt Nam*. Hanoi: Phụ nữ, 1982.

George Finlayson, *The Mission to Siam, and Huế, the capital of Cochin China, in the Years 1821–2.* Singapore: Oxford University Press, 1988.

Harry A. Franck, *East of Siam: Ramblings in the Five Divisions of French Indo-China*. London: T. Fisher Unwin, 1926.

H. J. Goodacre and A. P. Pritchard, *Guide to the Department of Oriental Manuscripts and Printed Books*. London: British Museum Press, 1977.

Hà Y. 'Rồng: vật tổ của dân Việt' in *Quê Mẹ*, Số 88–89, 1988, pp. 9–10.

P. R. Harris, *A History of the British Museum Library 1753–1973*. London: British Library, 1998.

Jessica Harrison-Hall et al., *Vietnam Behind the Lines: Images from the War, 1965–1975*. London: British Museum Press, 2002.

Patricia Herbert and Anthony Milner (eds), *South-East Asia: Languages and Literatures: A Select Guide*. Arran: Kiscadale Publications, 1988.

Pierre Huard and Maurice Durand, *Connaissance du Viet-Nam*. Paris: Imprimerie Nationale, 1954.

Hue Tam Ho Tai, *Radicalism and the Origins of the Vietnamese Revolution*. Cambridge, MA: Harvard University Press, 1992.

Hữu Ngọc, *Wandering through Vietnamese Culture*. Hanoi: Thế Giới, 2012.

Kim Văn Kiều, translated by Lê Xuân Thủy. Fort Smith, AZ: Sống Mới, [1960?].

Ký Họa Về Đông Dương: Nam Kỳ. TP. Ho Chi Minh: Nhà xuất bản văn hóa văn nghệ, 2015.

Le Thanh Thuy. 'Trade Relations between the United Kingdom and Vietnam in the 17th–19th Centuries', *Vietnam Social Sciences*, Vol. 3, No. 161 (2014), pp. 59–73.

Colin Mackerras, 'Theatre in Vietnam', *Asian Theatre Journal*, Vol.4, No. 1 (Spring 1987), pp. 1–28.

David G Marr. *Vietnamese Tradition on Trial 1920–1945*. Berkeley: University of California Press, 1984.

Alexandre Henri Mouhot, *Travels in the Central Parts of Indo-China, Cambodia and Laos during the Years 1858, 1859 and 1860*. London, 1864.

Frederick Arthur Neale, *Narrative of a Residence at the Capital of the*

Kingdom of Siam. London: Office of the National Illustrated Library, 1852.

Ngô Đức Thịnh, *Traditional Costumes of Viet Nam*. Hanoi: Thế giới, 2009.

Nguyễn Du, *Truyện Kiều: thơ và tranh*. Nguyễn Thạch Giang, dịch. Hanoi: Văn học, 2010.

Nathalie Huynh Chau Nguyen, *Vietnamese Voices: Gender and Cultural identity in the Vietnamese Francophone Novel*. DeKalb, IL: Northern Illinois University Press, 2003.

Nguyễn Ngọc Thọ, *The Symbol of the Dragon and Ways to Shape Cultural Identities in Vietnam and Japan*. Harvard-Yenching Institute Working Paper Series, 2015 (available online).

Henri Oger, *Introduction générale a l'étude de la technique du peuple annamite*. Paris: Geuthner Librarie-Éditeur, [1909].

Phùng Hồng, 'Rồng trong đời sống Việt Nam' in *Hồn Việt*, Vol. 25, No. 196/7 (2000), pp. 63–6.

Sixty Years of the Vietnamese Government 1945–2005. Hanoi: VNA Publishing House, 2005.

Ta Quang Khôi, 'Nhân vật truyện *Kiều*', in *Hồn Việt*, Vol. 36, No. 323/4 (2011), pp. 138–43.

Nicholas Tarling, 'Anglo-Dutch Relations in Southeast Asia (Seventeenth to Twentieth Centuries)' in Ooi Keat Gin (ed.), *Southeast Asia: A Historical Encyclopaedia from Angkor Wat to East Timor*. Santa Barbara, California: ABC CLIO, 2004, pp. 158–62.

Mary Ann Tétreault, 'Women and Revolution in Vietnam' in Kathleen Barry (ed.), *Vietnam's Women in Transition*. London: Macmillan Press, 1996.

Trần Đinh Sơn, *Đại lễ phục Việt Nam thời Nguyễn 1802–1945*. Hanoi: Nhà xuất bản hồng Đức, 2013.

Trần Nghĩa, 'Sách Hán-Nôm tại thư viện vương quốc Anh' ['Books

in Sino-Vietnamese at the British Library'], *Tạp chí Hán-Nôm*, Vol. 3, No. 24 (1995), pp. 3–14.

Trịnh Khắc Mạnh, *Chợ truyền thống Việt Nam qua tư liệu văn bia*. Hanoi: Khoa học xã hội, 2015.

Brantly Womack, *China and Vietnam: The Politics of Asymmetry*. Cambridge and New York: Cambridge University Press, 2006.

Alexander Barton Woodside, *Vietnam and the Chinese Model*. Cambridge, MA: Harvard University Press, 1988.

Zeng Zen, 'Năm thìn bàn chuyện rồng' in *Hồn Việt*, Vol. 25, No. 196/7 (2000), pp. 45–8.

Two websites on American art and propaganda from the Vietnam War:

http://vietnamwar.cloudworth.com/art-and-propaganda.php

http://reactingtovietnam.wikispaces.com./American+art+of+the+Vietnam+Era

Periodicals:

Báo Ảnh Việt Nam. Hanoi: Thông tấn xã Việt Nam, 1954–

Làng Văn. Toronto: Nhà in và xuất bản Việt, 1984–

Lửa Việt. Toronto: Cộng đồng người Việt tự do, [1980?]

Mỹ Thuật. Hanoi: Hội mỹ thuật Việt Nam, 1977–

Văn hóa nghệ thuật. Hanoi: Tiến bộ, 1971–